HAUNTED LANSING

HAUNTED LANSING

JENN CARPENTER

PHOTOGRAPHY BY ERICA COOPER

Published by Haunted America
A Division of The History Press
Charleston, SC
www.historypress.net

Copyright © 2018 by Jennifer Carpenter
All rights reserved

Cover photography courtesy of Erica Cooper.

First published 2018

Manufactured in the United States

ISBN 9781467140478

Library of Congress Control Number: 2018942433

Notice: The information in this book is true and complete to the best of our knowledge. It is offered without guarantee on the part of the author or The History Press. The author and The History Press disclaim all liability in connection with the use of this book.

All rights reserved. No part of this book may be reproduced or transmitted in any form whatsoever without prior written permission from the publisher except in the case of brief quotations embodied in critical articles and reviews.

For my parents, who have always encouraged my weirdness and creativity. Mom, thanks for reading me my very first book (and the thousand after that). Dad, thank you for telling me my very first ghost story (and the thousand after that).

CONTENTS

Preface	9
Acknowledgements	13
Introduction	15
Lady of the Manor	21
The Curse of the Fallen	31
See No Evil	37
Deadman's Hill	43
The Wolf in Sheep's Clothing	46
Wrong Side of the Tracks	54
Bad Medicine	59
Fire and Ice	62
From the Depths	66
A Lesson in Evil	71
City of Fire	74
The Legend of Seven Gables	82
An Ancient Evil	88
The Haunting of Minnie Haha	91
Criminal Intent	93
Mad Martha	100
The Blood Curse	104
House of a Thousand Corpses	108
Little Girl Lost	116

Contents

What Lies Beneath	121
Blessed Be	127
The Monster under the Bed	130
Conclusion	135
Resources	139
About the Author	141

Preface

Do you remember your very first ghost story? The one that kept you up at night for weeks? That sticks with you even now, years later? I remember mine. I was seven, maybe eight years old, out running errands with my father. We were at a shop just down the street from our home in Lansing, waiting on the salesman to ring us up. I was an antsy child, always pacing, fidgeting and getting into things. I was watching out the store's giant windows as cars passed by, but my proximity to the front door made my father uncomfortable. This was the 1980s, after all, when child abductions were rampant in the Midwest. He ordered me to stay by his side, which I did for a time. But I just couldn't stand still. To avoid being hollered at again, I wandered in the opposite direction, toward the back of the building and the staircase that led to the second floor. I'd been in that particular store dozens of times but never upstairs. What was up there? Hopefully something more exciting than waterbed parts. (1980s, remember?)

The stairs were covered in a layer of dust and looked like they hadn't been traversed in years. The white paint was scarred and chipped, the rubber grips peeling up at the corners. The higher the stairs went, the less the sunlight beaming through the store's front windows reached them. The top steps were so dark, I couldn't see where they ended. My little heart was pounding as I began to nervously twirl my ponytail with one hand and gripped the railing with the other. I took one step, then another. The store seemed a world away now, and I could barely hear the murmur of voices

Preface

in the background. My third step echoed up the stairs, and I wondered if anyone heard it. I could see that there was a door at the top of the stairs, closed and probably locked. But what, or who, was on the other side of it? I had to find out. As I took another step, I thought I heard a noise from behind the door—the quiet, soft lilt of a woman's voice. Except there were no women in the store. Just the waterbed salesman, my dad and me. Even as far away from them as I was, I would have heard it if someone else entered the building. The door chime was obnoxiously loud. I looked behind me and saw that I was halfway up the stairs. No turning back now. I balled my clammy hands into fists and took a deep breath, but before I could take another step, a strong hand wrapped around my elbow.

"What are you doing?" my father scolded me as he pulled me back down the stairs. "You don't want to go up there." I didn't say a word as he led me past the rows of waterbeds and out the front door. He held my hand tightly as we walked to the car, warning me about how I couldn't go wandering off whenever I felt like it. I don't remember much of what he said, just that I had to run to keep pace with him, and that the car's upholstery burned the backs of my legs as I slid across the bench seat of our powder-blue Buick LeSabre. I knew he was upset with me and it would be best to just be quiet on the ride home, but I was never one to hold my tongue when I had a question. We would be home in less than five minutes, and once we got there, Dad would be busy working on his bed and I would lose my chance. The time was now.

"Why?" I asked him, my voice squeaking a bit.

"Why, what?" he grumbled, pinching an unlit cigarette between his lips as he cranked his window down.

"Why don't I want to go up there?" He glanced over at me just briefly as he pulled the red-hot lighter from the dash and pressed it to his cigarette.

"Because somebody died up there," he whispered, as though he was letting me in on some big secret. My thoughts immediately turned to the clerk at the waterbed store. He seemed too boring to be a murderer.

"Somebody died up there?"

My father smiled as he nodded. "When I was right about your age. That waterbed store used to be a liquor store, and the man who owned it lived upstairs with his wife. Well, one day, he came home and found her…found out that she had a boyfriend. And he got really, really mad. So he killed her."

"He *killed* her?"

"Shot her dead." He made a gun out of his thumb and forefinger. "*Bang!* And then you know what he did?" I shook my head, my eyes wide. "He

reopened his store the very next day. Can you believe it?" I couldn't. It was the worst thing I'd ever heard and, arguably, not the type of story a father should tell his little girl. But I was fascinated.

"Is she still up there?" I asked.

My father laughed. "No, this was a long time ago. She's buried in a cemetery somewhere, I'm sure." I didn't believe him. I couldn't stop thinking about the noise I'd heard when I was going up the stairs, the sound of a woman's voice.

"What's up there now?" I asked as we pulled into our driveway.

He shrugged. "Probably just waterbeds and whatnot." He got out of the car, then came around to my side to open my door for me. I wanted to tell him what I'd heard, to ask him if he thought maybe the woman's ghost was still there, upstairs all alone. But he had things to do, and I was already freaked out enough. So I didn't ask. Instead, I let my imagination run wild. And for the next few years, anytime I had a creative writing assignment at school, I wrote about the ghost of the woman that lived above the store where she was killed. You know, typical eight-year-old fodder.

My love of the macabre was born on that hot summer afternoon, driving down Pleasant Grove Road with my father. To this day, whenever I drive past that building (which is now a barbershop), I look toward the upstairs windows, wondering if I'll see her looking back at me. I've heard countless ghost stories about the Lansing area since then, but I'll never forget my very first.

Acknowledgements

A book like this doesn't happen without A TON of assistance and support, and I have so many people to thank. First and foremost, my husband Dax, and our boys, Austin, Ethan, Chris, and Nick, for holding down the fort while I spent countless nights at my desk, banging my head against my keyboard. Thank you guys, and I love you. To Erica Cooper of Erica Jo Photography, thank you so much for the beautiful photos and for accompanying me on so many research and recon adventures—it made things so much more interesting. Thank you to all of my friends and family members who helped with feedback, proofreading, research and suggestions. You guys rock! To all of my friends in the paranormal community: Gary Gierke of the Michigan Area Paranormal Society, Medium Cat Ryan, Mark Briones of Marter Paranormal Research Team, Christine Peaphon of Mid-Michigan Paranormal Researchers, Motor City Medium Rebecca Smuk and Keith Daniel of Michigan State Paranormal Investigations—I truly could not have done this without your help and insight, thank you all. To the wonderful organizations that assisted me with research—Barbara Loyer with the Turner Dodge House and Heritage Center, Heidi Butler with the Capital Area District Library/Forest Parke Library and Archives, Julie Kimmer with the Courthouse Square Association and Kelen Gailey with the Dansville Michigan Historical Society—your commitment to preserving and sharing history is greatly appreciated. It truly takes a village, and I would be lost without mine.

Introduction

The city of Lansing has been Michigan's heart and soul for the past 150 years. A booming metropolis with over 100,000 residents, it's the fifth-largest city in the mitten state. It is home to Michigan's capitol building and is a driving force in the auto industry, producing more cars per year than any other city in North America. But in the early 1800s, the Lansing area was nothing more than a howling wilderness, inhabited only by the Native Americans who lived along the Grand River. We've all heard ghost stories that begin with a house being built on a Native American burial ground, but what about an entire city built atop the ruins of a sacred tribal community, burial grounds and all? Native Americans are often relegated to a single sentence in the story of Lansing's history, overshadowed by a sordid tale of swindlers, criminals and corrupt government officials. But as the very first settlers in the area, their time in Lansing was significant, and their legacy refuses to stay buried.

Legend has it that in 1835, two brothers from Lansing, New York, came to town looking to build a new city. They claimed and plotted an area of land on what is now the southeast side of Lansing and named it Biddle City. They then returned to their hometown in New York and began to sell the plots of land, even though Biddle City was almost completely underwater. Of course, they didn't tell their unsuspecting victims this. They told their friends and neighbors that Biddle City was a wonderful place with a town square, a church and sixty-five blocks of land, ready and waiting for them to build homes on.

Introduction

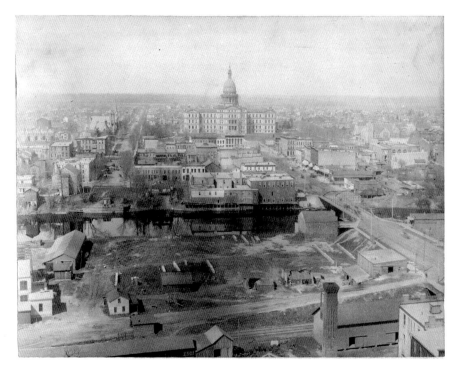

An aerial view of downtown Lansing in its early days. *Courtesy of CADL/FPLA.*

The nineteenth century was a time of tremendous change and growth for the United States, and the desire to build a new life in a new land was downright contagious. So with stars in their eyes and the hope that they could find success somewhere new, sixteen men traveled from Lansing, New York, to Biddle City, Michigan, to claim their piece of the American dream. But when they reached their destination in late 1836, they found that their new home was nothing more than a swampy nightmare. They had been scammed. Ashamed and unwilling to make the dreadful trip by wagon back to New York, most of the brothers' victims decided to stay in the area, settling near what is now downtown Lansing. They renamed the area Lansing Township in honor of their hometown in New York and set about building the life they were promised.

The thing about legends is, they're not always completely accurate. The doomed settlement of Biddle City was in fact owned by two brothers, William and Jerry Ford from Jackson, Michigan, but they were not scam artists. They were entrepreneurs and businessmen who built foundries and mills all over

Introduction

Jackson and Eaton Counties before deciding to build a city in the wilderness that was Ingham County. They sold twenty-one plots of land to residents from their hometown of Jackson, as well as families from Detroit, Chicago and other surrounding areas—but not to anyone in New York. The last plot of land was sold in 1837 during a time of great financial hardship for the Ford brothers, who had heavily mortgaged Biddle City before it was even a fully formed town. They wound up losing it when it was sold to pay off back taxes, so the landowners with no land were forced to make their homes elsewhere in the Lansing area. This early settlement of fewer than twenty people was able to live in relative peace with the local Ojibwa tribe, which inhabited well-established camps along the river. But things were changing fast in Michigan, and it wasn't long before a series of unfortunate events led to Lansing Township being thrust into the spotlight, changing its fate and that of the entire state forever.

Michigan's first capitol was in Detroit, the largest city in the state. But the 1800s were a wild time for Michigan, and the city of Detroit had the embarrassing distinction of being the only American city to ever surrender to enemy forces during wartime, which happened during the War of 1812. Though the United States quickly regained control of its lost city, British troops continued to occupy the banks of the Detroit River well into the late 1800s. As a result, politicians decided it would be wise to move the state capitol inland, away from the international border. The search for Michigan's new capital city was on.

Every established city in Michigan was vying to become the capitol's next home, from Ann Arbor to the U.P. With so many thriving cities in the running, Michiganders thought it was a joke when it was announced that the new state capitol would be built in a dense forest in the middle of a city that legislators hastily named Michigan, Michigan. Lawmakers laughed, in fact, when this no-man's land was first chosen. The senate was so against moving the capitol to Michigan, Michigan, that the body voted against it twenty-six times. Surely, it had to be a joke. The only thing resembling a community anywhere near the capitol's new home was the settlement of Lansing Township, which had fewer than two dozen residents, no carriage roads or railroads, and was overrun by savages. But it was no joke, and in 1847, the first of two capitol buildings was built in Michigan, Michigan. Once the temporary capitol was established, construction began on the permanent building. The quickly growing city was eventually renamed after the township that it swallowed up when the government came to town. Thus, Lansing was born.

Introduction

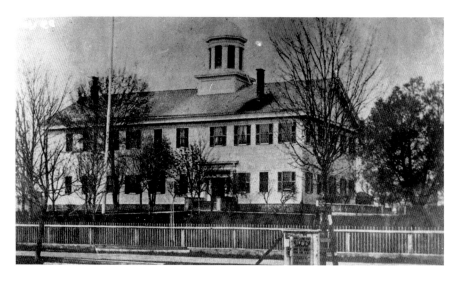

Lansing's first capitol building, circa 1847. *Courtesy of CADL/FPLA.*

But what of those Native Americans who had called the area home for centuries? Their world was upended virtually overnight, their land invaded by strangers. As settlers flooded into town, they claimed land that was already inhabited, tore down forests, erected buildings and houses, cut out paths for roads, eradicated wildlife. The Ojibwa weren't viewed as people; instead, they were merely troublesome creatures living in the wild country that entrepreneurs wanted to build on. Many natives relocated to northern Michigan, where there were still established tribes living essentially unbothered. Some made deals with their new neighbors, exchanging land for goods and money. Occasionally, these deals were honored, but most times they were not. Others were forced off their land, leaving everything behind—their homes, their belongings, their dead, even their chief—as they fled. It's said they left something else behind, too. According to local lore, Native Americans cursed the land that was stolen from them, casting a dark cloud over Lansing's dawning era. Many say these curses are to blame for the strange happenings and unexplainable catastrophes that have plagued the area ever since.

In a park along the river, where natives were said to stash stolen horses, paranormal investigators have picked up EVPs of tribal chants and songs on multiple occasions. Just south of Lansing, where a small group of Potawatomi was rounded up and forcibly removed from the land as part of the Trail of Death in the 1800s, a den of snakes is said to infest the

Introduction

river, appearing only when residents enter the water and disappearing just as quickly. The great Chief Okemos, who refused to be forced out of the area when Lansing was invaded by civilization, was said to have cursed a number of homes and buildings as a matter of pride, many of which have been afflicted by strange goings-on ever since. The Ojibwa chief lived to be well over one hundred years old. When he died in 1858, Lansing had been the capital city for just over a decade. He'd seen his settlement demolished, his people scattered, his sacred monuments desecrated. He was considered homeless, and once his trade business upended upon the arrival of department stores, he had no means of supporting himself, so he often relied on the kindness of Lansing residents for food and shelter. But Okemos was a proud man, and when he was offered a spot in the barn to sleep instead of in front of the fireplace, or a meal to-go rather than a seat at the table, he was insulted. He would often shout in broken English about how he was "once great warrior" or "once ruler of all land," then perform a curse on the house or business that had belittled him and storm off. All over the Lansing area, Native American artifacts are unearthed in backyards, at building sites and in parks—especially those near the river. Is it possible that, along with tangible relics, the natives left spiritual remnants behind as well?

Thanks to Hollywood, we've all seen what happens when you build a house on top of a Native American burial ground. So what happens when you steal an entire community from one of their tribes, chase them out of town, wipe out their legacy and then topple their homes and burial grounds to build a city? Read on to find out.

LADY OF THE MANOR

It's almost too easy to fall in love with the Turner-Dodge House and Heritage Center in Lansing's Old Town. The grand staircase, the spacious ballroom, the intricate woodwork. Stepping through the front doors is like stepping back in time. And yet, for all its grandeur, it still has a very homey feel—until the lights go out, at least. Built prior to the state capitol, it is one of the oldest buildings in Lansing and was home to one of the city's founding families for over one hundred years. There are reminders of the Turner and Dodge families throughout every room of the sprawling abode, but some say it's more than that. There are those who believe that the Turners and Dodges themselves still take up residence in the historic halls of their former home. And why shouldn't they? Many of them lived wonderful, full lives in that house. And sadly, many of them died there.

Marion Munroe was born in Amhurst, New York, in December 1818. The eldest of eleven children born to Jesse and Harriet Munroe, she and her family made the mass exodus from New York to Michigan in the mid-1830s. The Munroes were some of the first settlers in Eagle, Michigan, in 1836—before there were roads, schools or churches in the area. Marion Munroe was actually the first teacher in Eagle, her schoolhouse nothing more than a small log cabin near her family home.

In 1838, Marion and one of her sisters made the journey from Eagle to Mason to visit friends. The trip was not an easy one. They rode on horseback for hours through floodplains and backwoods. On their journey home, they traveled along the Grand River, which was home to dense forests, small

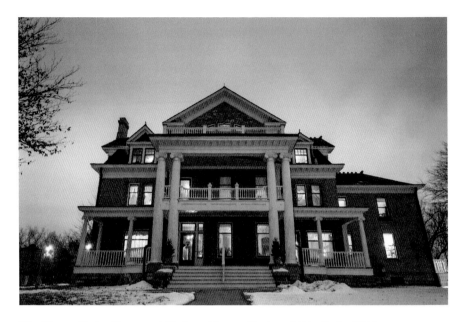

The Turner-Dodge House and Heritage Center. *Courtesy of Erica Cooper, 2018.*

tribes of Native Americans and not much else. Midday, they stopped along the river for lunch. As she admired the view of the roaring river and wide open space, Marion mused, "Someday, when I'm married, I think I'll make my home here." Thus, her love affair with the sprawling plot of land on the banks of the Grand River began. It continues to this day.

On October 1, 1843, twenty-four-year-old Marion married a twenty-three-year-old merchant and entrepreneur by the name of James Turner. Together, they lived in a small home in Mason, Michigan, until it was announced that a new capitol building would be built in the practically nonexistent city of Lansing (still regrettably called Michigan, Michigan, at the time.) Marion remembered the area fondly. James had fought tirelessly for this development and saw the potential for tremendous success, as an entire city would need to be built around this new capitol. So the young couple moved to Lansing in 1847. When the construction of their dream home was completed in 1858, Marion and James set about raising their family and helping build a city. And they did it all from the exact location Marion had picked out nearly twenty years prior.

James and Marion had ten children together. They were a true pioneer family and quite literally helped blaze the trails of Lansing, creating paths

through rugged woods that are now some of the main roads in the city. They helped ford the rivers and were instrumental in bringing plank roads and railroads to the area. They founded churches and schools and were active in social circles and local politics. James served as the deputy treasurer, a state senator and president of the Lansing Board of Education. He helped found the Michigan Female College, and his son James Jr. even served as mayor of Lansing in the late 1800s. The Turners were considered incredibly progressive for their time. They were abolitionists and suffragists, made friends with the Native Americans living in the area and were committed to quality education for all. Their home was known as the House of Kind Hearts. James and Marion took in and adopted many of their nieces and nephews, and everyone from politicians and former slaves to the great Chief Okemos were said to have dined at their table. The Turners were absolutely vital to the building of Lansing's infrastructure. They were well known and well loved by everyone in town. And then tragedy struck.

On October 1, 1869, his and Marion's twenty-sixth wedding anniversary, forty-nine-year-old James Turner died of typhoid fever. Everything he accomplished in Lansing he did over the course of just about twenty years,

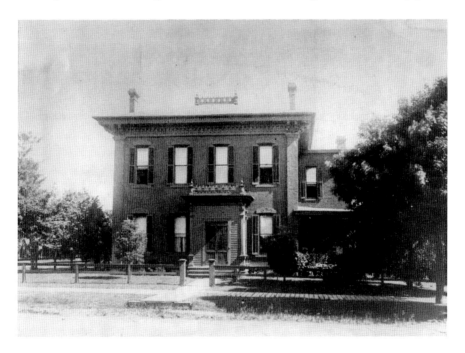

The Turner-Dodge House, circa 1890. *Courtesy of CADL/FPLA.*

which is pretty amazing. Though it is more likely than not, it's unclear whether James passed away in the Turner house. His funeral, however, was held in the foyer of the home, his body laid out in wake for the entire community to mourn. And his wasn't the only funeral to be held in the mansion.

In 1884, James and Marion's thirty-two-year-old daughter Addie passed away in her bedroom after a lifelong illness. At the time of her death, a local newspaper reported: "Addie is the seventh member of this family who, one by one, have taken up their abode in the silent halls of death, and left others to mourn their loss." Those deaths included the Turners' eldest child, Lucien; their first daughter, Harriet; daughters Jennie and Anna; and the youngest of the Turner children, Jesse, who was killed at the age of eleven in a tragic accident involving a horse and buggy. Marion Turner outlived all but three of her children—daughters Marion, Eva and Abigail. The Turner women were strong, many of them living well into old age. But the Turners' sons all died young, just as their father did. Lucien is believed to have died as a young boy like his brother Jesse, and James Jr. died of heart failure at the age of forty-six. Despite her tremendous losses over the years, Marion Turner continued her philanthropic work and remained a pillar of the community.

In 1889, Marion sold the family home to her youngest daughter, Abigail, and Abigail's husband, Frank Dodge. It is often said that women marry men who remind them of their fathers. This proved true in the case of Abigail Turner-Dodge. Her husband, Frank, was an entrepreneur, a lawyer and a staunch supporter of civil rights, just like James Turner had been. He was well known in legal and political circles and served multiple terms as city council president. When he and Abby purchased her family's home, they had major renovations done, turning it into the masterpiece it is today. And on the second floor, right at the top of the stairs, they built a bedroom for Abby's mother, Marion. In that room, Marion would sing to her grandchildren and tell them stories about the pioneer days and Chief Okemos and how she and her husband helped build the city of Lansing, both literally and figuratively. And in that room Marion would die, at the age of ninety-three. Her funeral was held in the foyer, just as her husband's and children's had been. For nearly seventy-five years, from the time she first set her eyes on that random plot of land on the Grand River until most of her children had grown and passed on and even some of her grandchildren had grown and passed on, the Turner-Dodge House was Marion Turner's home. So why would she leave it, even in death? There is evidence to support that she never did. Many believe that she still resides there to this day.

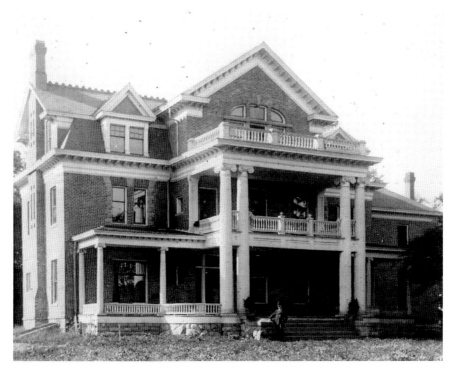

The Turner-Dodge House in 1903, following renovations. *Courtesy of CADL/FPLA.*

So if you ever find yourself in Marion Turner's bedroom, don't be surprised if you hear the fireplace seem to roar to life, even though it hasn't been used in decades. It's happened on several occasions. One time, it shuddered with such force that the entire room shook, causing an unsuspecting employee and volunteer to jump out of their chairs and run from the room. You might find yourself overcome with the urge to sing a song or sit down and read a story, as those were some of Marion's favorite things to do when her grandchildren were young. Many old books still line the walls of the room today. Once, an employee picked up a song book to move it and suddenly started to sing an old-fashioned song she'd never heard before. She sang the melody beautifully and word for word. She recalled later that it was almost as if someone was singing through her. It's also said that Marion's room has a calming effect on children. Once, a couple and their young son were touring the home as a possible venue for the couple's wedding. The boy was visibly uncomfortable from the moment he stepped foot inside the house. As they went from room to room, he was fidgety and

whiny, repeatedly complaining about how he didn't like being there. Despite the boy's misgivings, his parents decided to book the house as their wedding venue. They went into Marion's room, which doubles as the office, to sign paperwork. The little boy sat down in a chair and instantly relaxed, saying, "I feel okay in here." Was it Marion's spirit that had a calming effect on the boy? Maybe. When Christine Peaphon, a renowned psychic and the founder of Mid-Michigan Paranormal Researchers, visited the house for the first time, she saw the spirit of an elderly woman at the top of the stairs, coming out of what was once Marion Turner's bedroom.

Just a few years back, while employees and volunteers were preparing the house for a big event, a ringing bell seemed to follow them through the house. It sounded much like the dinner bell that Marion would ring to round up her children during mealtime back in the 1800s. It rang twice in the music room as they dusted and cleaned, then later in the guest room as they straightened up in there. Later, in what is known as the little boys' bedroom, they were looking over old news clippings about the family when the bell rang above their heads so loudly that it seemed to cause a vibration in the air around them. The next day, just as the event began, the bell rang twice more and then was never heard again. Every effort was made to find out what caused the ringing, but no explanation was ever found.

Once, a caretaker was changing a light bulb in the butler's pantry when a voice whispered, "Turn your head." No sooner did the caretaker turn her head than the lightbulb exploded, sending tiny shards of glass in all directions. Had she not turned her head as instructed, the glass would have gone right into her eyes. Quite a motherly thing for a spirit to do, no? If Marion Turner is still haunting her mansion, she's not alone.

Abigail Turner-Dodge, James and Marion's youngest daughter, was born in the house, married in the house and died in the house. As a young girl, she went to art school in Berlin. She was a well-known musician in the Lansing area along with her sister Eva, who was a singer. Abby's piano and pump organ remain in the house today, longing to be played. Or is it Abby who longs to play them? Don't get too close to her pump organ in the ballroom, or you might find your hands overtaken for a spell. It happened to one guest of the home who had never played the piano in her life. She sat down at Abby's organ and found herself playing the most beautiful song she'd never heard. She played the phantom song once, flawlessly, and then was never able to play it again or even recall the exact melody.

It's been said that sometimes, if you're very quiet, you'll hear the sound of little girls laughing and playing on the second floor. Could it be the

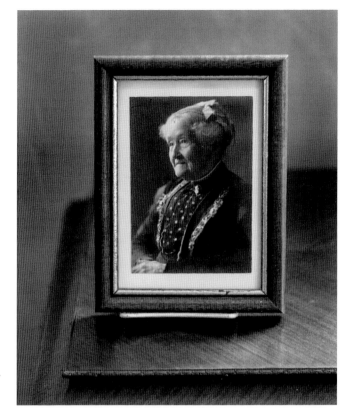

Right: Marion Turner in the late 1800s. *Courtesy of Erica Cooper, 2018.*

Below: Abigail Turner's piano in the grand ballroom. *Courtesy of Erica Cooper, 2018.*

childhood spirits of sisters Abby and Addie, who both died in the home? Or perhaps their siblings Jennie and Anna, who both passed away when they were very young?

On her first visit to the home, Motor City Medium Rebecca Smuk was admiring the boys' bedroom when a little boy peeked out from behind the doorway and whispered, "These aren't my things," talking about the antique toys and clothes that decorate the room. Was it Jesse, perhaps, the baby of the family who died when he was just a boy?

If you're ever on the stairs and hear rustling, don't worry. It's just the petticoat of a teenage servant girl running past you. She once surprised Mid-Michigan Paranormal Researchers' Christine Peaphon, who caught a glimpse of the girl out of the corner of her eye just before she disappeared. On another occasion, Terri Steele-Briones, co-founder of Marter Paranormal

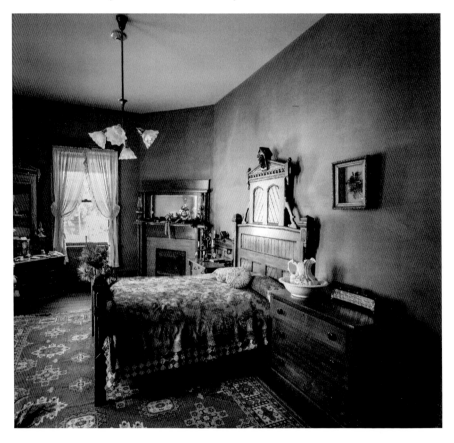

The guest bedroom at the Turner-Dodge House. *Courtesy of Erica Cooper, 2018.*

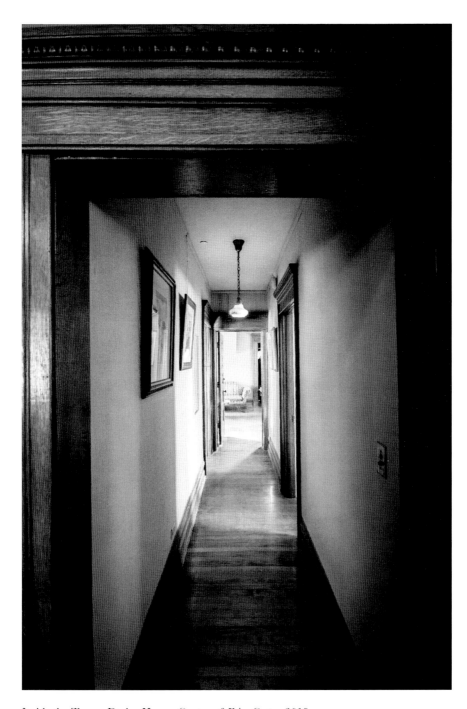

Inside the Turner-Dodge House. *Courtesy of Erica Cooper, 2018.*

Research Team, had just made note of a heavy feeling at the top of the stairs when she caught the image of a shadow person on a piece of surveillance equipment.

At the Turner-Dodge Mansion, it's not unusual to have an empty room fill with the scent of cigar smoke, even though there is no smoking allowed in the house. And guests often report hearing footsteps and the sound of children playing coming from the third-floor ballroom, even when there's nobody up there.

The guest room at the bottom of the third-floor stairs is said to be the room in the house that makes visitors the most uncomfortable. With a porcelain pitcher and bowl set that has moved on its own, that's not much of a surprise.

Frank and Abigail Dodge raised five children in the Turner-Dodge Mansion. In 1927, their daughter Sophie, a young wife and mother to two children, died at St. Lawrence Hospital in Lansing during a routine tonsillectomy. Something went wrong during the surgery, and she bled to death on the operating table. She was the first member of the Dodge family to die. Just two years later, family patriarch Frank passed away at the age of seventy-six, also at St. Lawrence Hospital. Three years after that, the Dodges' son Wyllis died at the age of thirty-nine. The funerals for all three members of the Dodge family were held in the mansion. Like her mother before her, Abigail Turner-Dodge outlived many members of her own family before she died in the house in 1947, at the age of eighty-six.

When Abigail passed away, the house went to her daughter Josephine McLean and her husband, Andrus. Together, the couple had three sons. The McLeans were the last members of the Turner-Dodge family to live in the home before it was sold to the Great Lakes Bible College in 1958, then the City of Lansing in 1974. The city maintains the house to this day, using it as a community events center.

But before the home became one of the most sought after wedding venues in Mid-Michigan, three generations of a prominent local family spent one hundred years in the Turner-Dodge Mansion, many of them living and dying there. Almost all of them had their funerals in the home. That's a lot of history and a lot of tragedy. While there seem to be many spirits still attached to this haunted abode, there is probably no attachment stronger than that of Marion Turner, who knew it was her home the first time she saw it, even though it was nothing but wild country at the time.

The Curse of the Fallen

The relocation of Michigan's capital city was wrought with enough dramatic twists to inspire a Shakespearean tragedy—an American city being captured by Canada without a fight, state legislators trying to bribe and bully their way into good favor so that their respective cities would be selected, a governor's mansion built in Marshall that would never be put to use, laughter throughout the ranks when an area of backwoods swampland was chosen, and the unfortunate naming of the new capital city as Michigan, Michigan. So when the state's third capitol building, which was modeled after the U.S. Capitol, was dedicated and opened to the public on January 1, 1879, politicians were hopeful that they could settle into business as usual. Their hope was short-lived, however, as tragedy was not far off. On December 16, 1882, Lansing's first capitol building burned to the ground. Less than a month later, Michigan's original capitol building in Detroit, which had been converted into the city's first high school, burned to the ground as well. Where once there were three, only one remained. "The Lion of Lansing" (as it was dubbed by locals) would not remain untouched by darkness for long.

While the new state capitol came with a built-in staff by way of elected politicians, new job opportunities were created as well. It took scores of secretaries, security officers, maintenance workers, janitors and the like to keep the pristine building running like clockwork. Probably one of the most coveted positions was that of the page boy. Dozens of local boys were hired to be messengers for the Michigan elite, transporting important documents

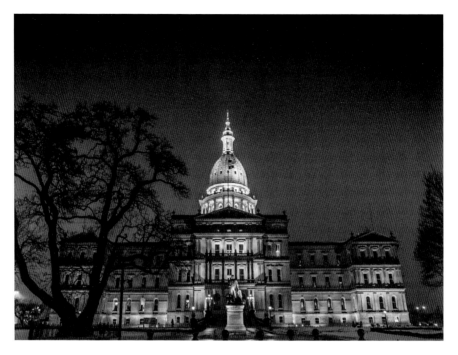

Michigan's state capitol building. *Courtesy of Erica Cooper, 2018.*

between offices at the capitol and other government buildings in the vicinity. This was seen as a fantastic opportunity for Lansing's youth, as the only work that had been available to them prior was manual labor. As page boys, they could earn favor with the most important men in the state—senators, mayors, governors. Being selected as a page boy at the capitol was seen as the first step to a bright future for many.

Still, boys will be boys. On February 10, 1881, just two years after the capitol building opened, a group of page boys found themselves with some downtime. The capitol was the biggest, most magnificent building any of them had ever seen, and they had countless adventures in its halls. On this particular day, they were jumping between the banisters of one of the building's many staircases. Among the boys was thirteen-year-old John Alburtas Clippinger, who was known as Bertie by his friends and family. As he attempted to jump across the solid mahogany banister leading from the fourth to third floors, Bertie slipped, toppling over the side of the railing. He fell four stories to the checkered marble tile below and was instantly killed—his neck and limbs broken, the bones in his face shattered. The community mourned his tragic death, and the building supervisor put out

a warning to parents to keep their children out of the capitol building, as it was no place for horseplay. Being a page boy became a much more somber job after Bertie's death, and one that was no longer granted to young boys but to college students attending school full-time.

Almost immediately following Bertie's accident, the rumors began. Folks claimed to see Bertie wandering the halls of the capitol, playing on the staircase where he died. People have reported sensing someone was behind them on the steps and feeling cold spots on the ground floor, where Bertie's broken body landed after his fall. Is it Bertie's love of the historic building that keeps him there? Or did the suddenness of his death leave him confused, unable to cross over? While Bertie Clippinger's death was the first at the state capitol, it would not be the last.

On March 27, 1936, four days before his thirty-sixth birthday, David Altman arrived at the capitol for a day of work. A mechanic for the Otis Elevator Company, he was helping upgrade the building's aging elevator. He was guiding a beam into the elevator shaft when it struck a live wire. It's believed that the jolt of electricity caused David to fall into the empty elevator shaft. When he hit the ground three stories below, he suffered a myriad of injuries, including internal bleeding, a fractured right hip and brain trauma. He died the following day in the hospital, leaving behind his

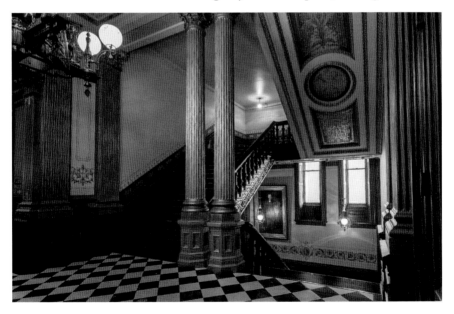

The staircase from which John "Bertie" Clippinger fell to his death. *Courtesy of Erica Cooper, 2018.*

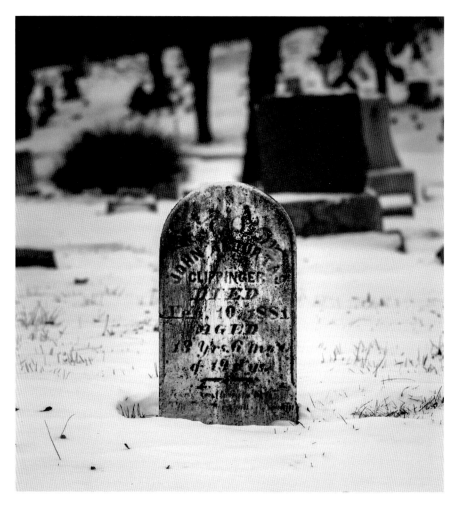

The grave of John Alburtas Clippinger. *Courtesy of Erica Cooper, 2018.*

wife, Thelma, and two-year-old son, David Jr. But did David fall, or was he pushed? Maybe by someone else who'd died in a falling accident in the same building several decades prior? Whatever the case, David's would not be the last falling death at the state capitol.

On March 31, 1992, almost fifty-six years to the day after David Altman's death, fifty-two-year-old tinsmith James Parady was working on restorations to the capitol's roof when he slipped and fell one hundred feet to his death. He left behind a wife and three children. It's said that his safety harness was detached just prior to his fall. But why would an experienced trade worker

The elevator where David Altman fell to his death in 1936. *Courtesy of Erica Cooper, 2018.*

do something as dangerous as remove his safety harness while on the roof of a building? Is it possible that someone else removed it for him?

In the building's nearly 140-year history, there have only been three documented deaths at the state capitol, all due to falling accidents. Can they all be attributed to a mischievous little boy who likes to play pranks and has been haunting the capitol for nearly as long as it's existed? Or is it possible, as some believe, that the capitol's curse of the fallen goes back even further than the death of Bertie Clippinger?

On June 28, 1875, during the initial construction of the capitol building, a section of scaffolding collapsed, sending the three construction workers standing on it flying about twenty feet to the ground below. While two of the workers were treated for minor injuries, thirty-year-old Thomas Zamosky suffered a broken back. He lived for two years after the accident, finally succumbing to his injuries at St. Mary's Hospital in Detroit in 1877. He died without ever seeing the completion of the building he gave his life for.

So while Bertie Clippinger's death is the most well known and remains the only documented death to occur *inside* the capitol, the falling deaths began before the building was even fully constructed. Is it merely coincidence? Or is there truly a curse of the fallen, as some believe?

Aside from the sightings of Bertie Clippinger that continue to this day, the ghost of James Parady is said to be seen wandering the rotunda, looking confused. The elevator in which David Altman died is said to have a volatile temperature, fluctuating between uncomfortably warm and freezing cold in just a matter of seconds. Paranormal investigators suggest that there is an unusually high amount of paranormal activity at the state capitol, although no one has ever been granted access to conduct a full-scale investigation.

Designated as one of the most haunted buildings in the state, the capitol is definitely worth a visit. Just be sure to watch your step while you're there. And keep your head up. You never know what might fall from the sky.

SEE NO EVIL

On the fringe of Lansing's Old Town sits a broken, abandoned building that was once home to broken, abandoned things. Formerly a magnificent work of neoclassical architecture, the three-story behemoth known as the Abigail is now one of the most foreboding landmarks in town. While its appearance alone is enough to spawn countless ghost stories and urban legends, those who have been inside it say the truth is even more terrifying. They believe there is something malevolent lurking within the halls of the abandoned building, an evil that doesn't have to be seen to be felt.

Over the last century, our world has become a more tolerant, welcoming place than it once was. We have made great strides in accommodating people with disabilities, resulting in them being able to lead full, happy lives. But prior to the twentieth century, having a disabled child was often considered a burden too great to bear, if not a disgrace to the family. Thus, imperfect children were locked away in sanitariums and asylums to live out their days under the most horrific of conditions. By the late 1800s, there were so many residents at the Michigan Asylum for Educating the Deaf, Dumb and Blind in Flint that officials found themselves in need of another facility.

As a result, the Michigan School for the Blind opened in Lansing on September 29, 1890, with thirty-five students enrolled in grades kindergarten through twelfth grade. Built on the former campus of the defunct Michigan Female College, most of the buildings were dilapidated and ill-equipped to accommodate blind children, including a monstrous structure known as Old

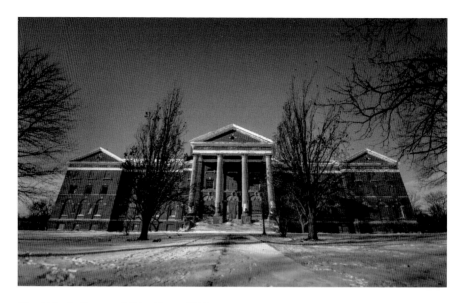

The Abigail. *Courtesy of Erica Cooper, 2018.*

Main. Old Main originally housed all of the school's students as well as the administration offices, despite the fact that it was falling apart. It was said to be "damp, foul-smelling, poorly ventilated, and altogether unhealthy" by one former employee. It was attached by treacherous underground tunnels to the other buildings on campus in equally poor repair. But as the student body increased over the years, so did funding for improvements. By the early 1900s, nearly all of the buildings at the Michigan School for the Blind had been updated or torn down and replaced altogether. Old Main was not spared. Keeping the bones of the layout and not much else, it was rebuilt as the Abigail, a giant Greek Revival–style building with a three-story gym and grand Doric columns lining the main entrance. The construction of the Abigail was seen as a tremendous improvement to the quality of life for the hundreds of students enrolled at the school, many of whom lived on campus full-time, all but forgotten by their families. At its peak, the Michigan School for the Blind boasted an enrollment of over three hundred students; it was home to world-famous Motown artist Stevie Wonder and won a state championship in high school wrestling. But over the years, as mainstream schools began accommodating students with disabilities, enrollment dwindled. The school shuttered its doors for good in 1995. And when a building as imposing as the Abigail is abandoned, it's inevitable that ghost stories will follow.

Some say that if you visit the Abigail at night, you'll hear moaning beneath the earth, as the restless souls of students lost in the underground tunnels taunt you to come play with them. One of the most well-known ghosts on campus is George, a former student and caretaker from the World War II era who is believed to have died on the property and simply never left. George is said to be a trickster who likes to move portraits and play with art sculptures at the Neighborhood Empowerment Center that now occupies one of the school's old buildings. Folks who have encountered George believe he is harmless and just enjoys the attention his antics bring him. According to one former caretaker, as long as you're sure to greet George by name every morning, he's pretty tame. It's when he feels ignored that paintings start spinning and things begin moving on their own. While George is considered a friendly ghost, the spirits that haunt the halls of the Abigail aren't as well liked.

Accessible only with special permission, a respirator, and steel-toed boots, the Abigail doesn't see a lot of activity these days. But once every so often, a hired crew ventures into the building to make sure no one has taken up illegal residence inside, even though, as one former caretaker put it, "No one has ever stayed there for more than twenty-four hours. The rest of the buildings, we have issues with from time to time. But not the Abigail. Even though it's

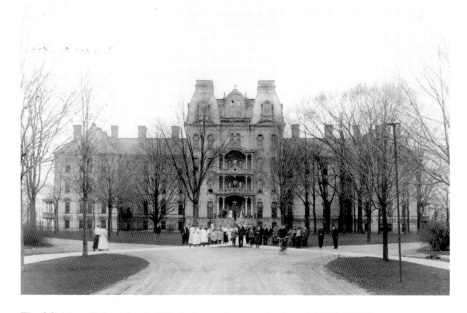

The Michigan School for the Blind, date unknown. *Courtesy of CADL/FPLA.*

the biggest building on the property, it's the one nobody seems to want to go near." While exploring an abandoned school might sound like a paranormal investigator's dream, it's not a job the caretakers have ever looked forward to. While all of the ancient buildings are in disrepair, dirty and dangerous, there's something different about the Abigail. Something malevolent, visitors claim. Something evil. Even just getting too close to the building has been known to send shivers down one's spine—but for those who dare to venture inside, the experience is often overwhelming. The enormous gymnasium, which was built into a hillside, is half in the dark, half in the light, giving it an eerie, otherworldly feel. Just outside the gym is an old janitor's closet with a system of hooks used for hanging cleaning supplies. On one walkthrough, a group of caretakers made a grisly discovery that none of them will soon forget. On the hooks once used for brooms and mops were rows and rows of animal carcasses—rotting, gutted, some of them skinned. As unsettling as that was, the caretakers feared the basement even more. Dark, damp and littered with rusty bed frames belonging to former residents who were once locked away in the dungeon-like area, caretakers have stumbled upon blood, bones and other unexplainable signs of life—and death.

While much of the gore found within the Abigail can be attributed to squatters, the sense of dread and presence of evil that permeates the air cannot. What is it about the Abigail? Is it the tortured spirits of former students, forgotten by their families and shunned by society, doomed to spend eternity in the decrepit dormitories of their former school? Some believe the answers lie even further back in the Abigail's history.

Prior to becoming the Michigan School for the Blind, the campus was owned by an ancient secret society known as much for its macabre rituals as it was for its civic outreach programs. The Independent Order of Odd Fellows dates back to eighteenth-century London and touts King George IV as an early member. Today, according to the organization's website, the Odd Fellows are "men, women, and youth believing in a supreme being, the creator and preserver of the universe, who have come together in our local communities having the same beliefs and values as others—that friendship, love, and truth are the basic guidelines that we need to follow in our daily lives." Like other fraternal orders, much about the Odd Fellows is shrouded in mystery. But the organization does have some skeletons in its closet—quite literally.

When membership began to decline during the twentieth century, the Odd Fellows closed many lodges. These buildings were then sold to unsuspecting victims who had no idea the secrets they would unearth. There are reports

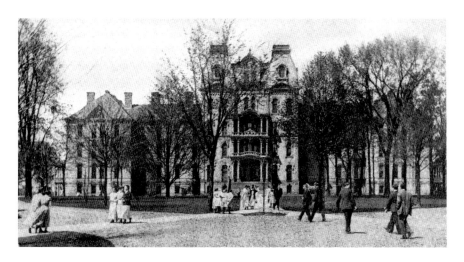

Students and staff at the Michigan School for the Blind, date unknown. *Courtesy of CADL/FPLA.*

from across the country of human remains found hidden in the walls, attics and basements of former Odd Fellows lodges. Lest there be any doubt about who put them there, the fully articulated skeletons, often entombed in caskets, were emblazoned with the letters FLT (friendship, love and truth) in three interlocking rings—the Odd Fellows insignia. Were the Odd Fellows murderers? Did some of their secret rituals involve human sacrifice? While the truth is definitely unsettling, it isn't quite that scandalous. The Odd Fellows' initiation ceremony involved a ritual in which a pledge would be left in a candle-lit room with a human skeleton to contemplate their own mortality. Where these skeletons came from, however, is unclear, as authorities have been unable to identify the remains in many of these strange cases. The Odd Fellows Hall in Lansing was intended to house indigent members of the order and their families, but was unable to secure the financial backing necessary to complete renovations. After only a few years, the order rented the property to the Michigan School for the Blind, eventually selling it to the school in the late 1800s, leaving untold secrets behind.

Another theory about the haunting of the Abigail involves the building's namesake, Abigail Rogers. Before the Michigan School for the Blind and before the Odd Fellows, the forty-acre plot of land that the Abigail lords over was the Michigan Female College. Founded in 1858 by Abigail Rogers and her sister Delia, the college was a functional resistance to the larger universities in the state, Michigan Agricultural College (now Michigan State University) and the University of Michigan. Since those schools refused to

admit women, the Rogers sisters opened a college that would. Over one thousand young women from around the country attended the Michigan Female College during the decade it was in operation. But when Abigail Rogers died in 1869, so did her dream. The Michigan Female College closed almost immediately after Abigail's death, and the land was donated to the Odd Fellows. Could the ghost of Abigail Rogers still haunt the halls of the building that was named after her? Is it possible that she's angry about the sad fate suffered by her beloved school and refuses to leave the grounds until they are well taken care of?

Abandoned children, broken dreams, secret societies—the Abigail has seen it all. Is it any wonder that locals believe the building to be haunted by the ghosts of its past? A shell of its former self, what's left of the Abigail stands stoically as it awaits its next mission, with developers looking to put it back to use in the community someday. But is it possible that some buildings, no matter how beautiful, are just better off left alone?

DEADMAN'S HILL

When a plot of land is given a name like Deadman's Hill, ghost stories are inevitable. Many local residents assume that the thirteen-acre park just south of Lansing was simply named after its steep terrain, but the truth is much more sinister. In reality, it's been known as Deadman's Hill since long before it became a public park—not because of the hill itself, but because of what's buried inside it. Known as one of the best places to go sledding in Mid-Michigan, Deadman's Hill is a popular destination for winter fun. But the park entertains visitors throughout the year, including those looking for signs of the restless spirit said to reside there.

Locals have reported an eerie, heavy feeling in the park, especially at night. It's common to feel as though you are being watched or see ghostly shadows moving between the trees. Some say that on a still night, you can hear a young man's mournful sobs rolling through the hills. Many believe that man to be John Taylor, whose horrific murder is still being talked about over 150 years after his death.

As he approached his eighteenth birthday, John Taylor had already lived quite a life. Born in Kentucky on August 27, 1848, to a young slave who'd been impregnated by her owner, Taylor was freed from slavery just in time to enlist as a Union soldier in the Civil War. He served on the front lines in South Carolina, then settled in Michigan when the war ended. With the $500 he earned during the war held in a trust until his twenty-first birthday, Taylor took a job as a day laborer on John Buck's farm in Delhi Township, south of Lansing, for $10 a month. But the conditions on the farm were less

Deadman's Hill in Holt. *Courtesy of Erica Cooper, 2018.*

than ideal, and when Taylor decided to leave the farm to find employment elsewhere, John Buck refused to pay the young man the full wages he owed him. Taylor left the farm in anger on his last day of work but returned later that evening to demand the money he was due.

Exactly what happened next remains unknown, but the story that circulated in the community was that John Taylor murdered John Buck's family, including his wife and daughter, with an axe. He was quickly apprehended and lodged in the Ingham County jail in Mason. An angry mob began to form in Delhi Township, outraged by the news that a black man had killed white women in their home. Leading the mob was none other than John Buck, who demanded to know why a man he'd been so kind to had "hacked his family to pieces." In reality, Buck knew his family was still alive. Reports vary on the nature of the altercation, with some officials reporting that not a single drop of blood was shed, while others claimed Buck's daughter suffered a brain injury she was not expected to recover from. Whatever injuries may or may not have been inflicted upon the women, they all made full recoveries and lived long lives.

But the mob of one hundred to two hundred men would hear none of it. Convinced John Taylor was a murderer, they stormed the Ingham County jail on August 23, 1866, overpowered Sheriff Fredrick Moody and took

the seventeen-year-old from his jail cell at gunpoint. They dragged him through the streets of Mason to the train depot on the corner of Mason and North Streets where they interrogated him, tortured him, shot him three times and eventually hanged him. His head was removed from his body and taken home by a local doctor, who kept it on display. His body was first buried in a field, but when the farmer who owned the land protested, it was dug up and moved to an area known as the hogsback. Four days before his eighteenth birthday, John Taylor was forever interred at what is now called Deadman's Hill for a murder he didn't commit, the victim of the only recorded lynching in Ingham County history.

Out of over one hundred people estimated to be involved in the lynching, just three were arrested, and only one ever stood trial. William Cook's first trial ended in a deadlocked jury. During his second trial, during which he was supported by then-governor Austin Blair, he was found not guilty. By the time court proceedings began, it was a well-known fact that no one in the Buck family had been killed, making the murder of John Taylor all the more egregious. Still, no one was ever held responsible for his death.

In 2018, talks began to rename Deadman's Hill after John Taylor and properly memorialize him with a statue or a plaque. If his spirit does in fact haunt his unmarked grave, perhaps proper recognition of his life, and his death, will allow him to cross over.

The Wolf in Sheep's Clothing

Few things are as joyous as the sound of children playing outside on a warm summer's day. Unless, of course, those children have been dead for nearly one hundred years, victims of the worst school massacre in American history. For decades, paranormal investigators have been flocking to a small farming community just outside of Lansing to visit the site of the Bath School Disaster, a memorial park that experts say is crawling with paranormal activity. But the residents of Bath are used to outsiders. The town has been a global spectacle since an unthinkable tragedy ripped the community apart on May 18, 1927. To make matters worse, the crime was perpetrated by the last person anyone suspected—a man that all the townspeople knew and trusted, especially those he wound up hurting the most.

By all accounts, it was a beautiful spring day in Bath. An overnight thunderstorm had cleansed the town, and children picked lilacs on their way to school to give their teachers. Consumers Energy was in town, finally bringing electricity to an area that had long been run on generators and manpower. The seniors and staff at Bath Consolidated School were preparing for commencement, which was to take place the following day. It was business as usual in the small town. And then the ground began to shake. A magnificent blast knocked people off their feet, blew out windows and toppled furniture. As folks ran from their homes, fearing an earthquake, they were greeted by unimaginable horror. The Bath Consolidated School, which was attended by all of the town's children in grades one through twelve,

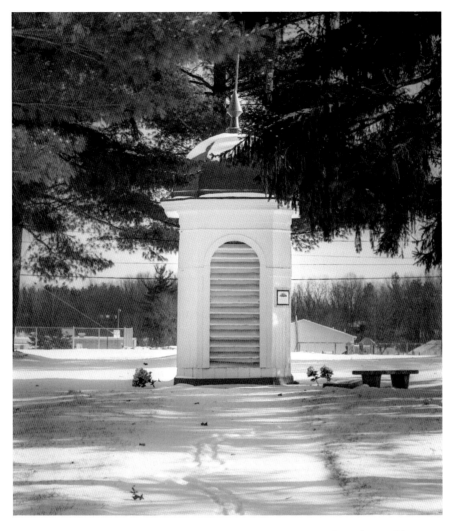

The cupola from the original school building still stands today at the Bath School Disaster Memorial Park. *Courtesy of Erica Cooper, 2018.*

was in ruins. An explosion of some sort had leveled the school and tossed children about like ragdolls. Their bodies (and body parts) were strewn about the school grounds, some buried by smoldering rubble. Word of the explosion spread quickly by way of frantic screams echoing through the air, and soon it seemed the town's entire population had descended upon the scene, many desperately looking for their loved ones, some eager to lend a helping hand, and others looking on in shock and disbelief.

Superintendent Emory Huyck, who was at the school overseeing a rehearsal for the following day's graduation ceremony, sprang into action. A group of frantic students had escaped onto a section of the school's roof, and he climbed up to help them down safely. A crew of rescuers found the third and fourth grade teacher, twenty-one-year-old Hazel Weatherby, buried up to her waist in rubble, each arm wrapped tightly around a student. Rescuers immediately recognized that the children were dead, and as soon as they were taken from Weatherby's arms, she died, too. A grieving mother sat quietly on a hill, holding three of her young children, two in her arms and one in her lap, all dead. Tiny victims were rescued from the ruins and rushed to the houses across the street from the school so that their injuries could be treated until they could be transported to the hospitals in Lansing. A makeshift morgue began to form on the grounds of the school as dead body after dead body was laid out for identification. There was so much going on, no one gave much thought to how the north half of the school might have exploded or what could have possibly happened. There simply wasn't time to consider it.

Amid the chaos, a familiar truck pulled up. Andrew Kehoe, the school board treasurer, had arrived to help. Though he didn't have children of his own, he was well known and well liked by the students at Bath Consolidated School. He was a jack of all trades—electrician, janitor, philanthropist. He was always at the school for one reason or another. Just the day before, the first grade class had held an end-of-the year picnic on his farm. He caught the attention of Superintendent Huyck and called him over to his truck. The two men had a long history of bad blood, but this was no time for petty grudges. They were in crisis mode. Huyck immediately tried to put Kehoe to work, telling him where help was needed. Kehoe's reply was chilling. "Alright," he said. "I'll take you with me." Horrified, Huyck realized that what happened at the school was no accident and Andrew Kehoe was responsible. Kehoe pulled a gun, and the two men began to fight, drawing the attention of the crowd. Kehoe managed to fire the gun into his truck, which was filled with explosives and metal shrapnel. The resulting explosion killed him, Emory Huyck and a number of other people as the town looked on in horror. There was no longer any question what had happened to their beloved school and their precious children. The only question now was why.

Andrew and Nellie Kehoe moved to Bath in 1919 after Nellie's uncle passed away, and they purchased his farm from the family estate. They were an older couple, the age of many grandparents in town, but had no children

of their own. Their three-story house was one of the finest around, and their farmland was some of the richest in the area. They became active in local social circles and befriended their neighbors. The other farmers were in awe of Kehoe's unorthodox farming methods. A highly skilled electrician, much of his equipment ran on gasoline, whereas others still used oxen and horses. Rather than coveralls and work boots, Kehoe did his farming in a three-piece suit and was never seen with a hair out of place. He was also an expert when it came to explosives, which farmers often used to blow up tree stumps and immovable boulders on their land.

Over time, however, those close to Kehoe began to see his dark side. He killed a neighbor's dog because it annoyed him. He put down one of his horses because it wasn't performing the way he needed it to. He regularly beat his animals and argued with neighbors and relatives over money. And he was hiding a darker secret, still.

Following Andrew's mother's death when he was eighteen, his father married a much younger woman, just three years Andrew's senior. Andrew and his new stepmother never got along. One day, she was in the kitchen cooking. When she turned on the stove, it exploded, engulfing her in oil and flames. Andrew, who was very knowledgeable about different types of fires, doused her with a bucket of water. This only spread the flames, as he most likely knew it would. He took his time seeking help from neighbors and was nonplussed when his father's wife passed away before his eyes. Years later, after he'd murdered dozens of children, this would come up again. People began saying his stepmother's death was no accident and that Andrew was behind it.

But the residents of Bath knew nothing of Andrew Kehoe's violent past when they elected him school board treasurer in 1924. His reputation as an intelligent, frugal member of the community made the appointment a no-brainer, and he easily won the three-year position in a local election.

The school system in Bath changed drastically in the 1920s. At the start of the decade, the community was dotted with one-room schoolhouses. In 1922, it opened the Bath Consolidated School, with all 236 of the school-aged children in Bath enrolled. This was seen as a huge step toward modernization for a town that was still without electricity, but the increase in property taxes to help pay for the school was a burden many residents were unhappy about, especially those without children like Andrew Kehoe. Kehoe blamed his excessive property taxes for the fact that he went years without making a mortgage payment and was in danger of losing his home. It seemed that every time a board meeting was

held, Superintendent Huyck was suggesting a tax increase for one thing or another that the school needed. This caused great tension between him and Kehoe, and the two argued often. The animosity got so bad, it was widely rumored that Kehoe had no chance of being reelected to a second term on the school board and his job as treasurer would soon end. On the heels of an unsuccessful bid for a vacant city clerk position, his political aspirations were dashed. He felt humiliated and betrayed by the town he'd given so much of his time to.

By late 1926, Andrew Kehoe's life was in a downward spiral. His farm had fallen into disarray, he was losing his political standing, and his wife was ill and had been in and out of the hospital, adding to their financial woes. So with the help of his unsuspecting friends and neighbors, he put into motion a plan to destroy the town. Kehoe was so respected and trusted, no one thought twice about him having his own key to the Consolidated School. No one thought twice about him coming and going at all hours of the day and night. He was always tinkering with something, be it a loose door handle or a major repair. No one batted an eye as he began to store large caches of dynamite and pyrotol (an explosive commonly used by farmers) that he collected from all over the state. He had a lot of land, after all, and was always clearing some section of it. It wasn't until the school blew up—and Andrew Kehoe with it—that his true intentions were realized.

The first sign of trouble on May 18, 1927, was a fire at the Kehoe farm. Neighbors heard several explosions and found fire and smoke pouring from the windows of Kehoe's house and barn. They also found Kehoe pulling out of his driveway as they were pulling in. "Get out of here, boys," he reportedly told them. "You're my friends. You better get down to the school." Before they had time to react, there was another, much larger explosion—this time from the direction of the school that Andrew Kehoe had just raced off to.

Investigators would later determine that over the course of several months, Kehoe had planted nearly one thousand pounds of explosives in the basement of the school and rigged them with an intricate timer system. Almost two hundred pounds of dynamite and pyrotol exploded at 8:45 a.m. on that fateful day, sending the north wing of the school and everything in it flying into the air, then crashing back down to earth. Many survivors reported that they didn't hear the blast, they just found themselves floating, suspended midair along with books, desks, pencils and their classmates, many of whom were dead by the time rescuers dug them out of the rubble. Over at the Kehoe farm, rescuers searched in vain for

Andrew's wife, Nellie, only to find her charred remains in a wheelbarrow near the barn three days after the bombing, along with a handmade sign that said, "Criminals are made, not born," attached to a fence.

Forty-five people were killed in the Bath School Disaster, most of them children in second through sixth grades, making it the deadliest school massacre in American history to date. Andrew Kehoe was the first suicide bomber in the United States, having carried out his crime before the terminology for it even existed. The scars left on the Bath community by the events of that day are indelible. You can feel the pain and sadness the moment you step onto the grounds of the Bath Consolidated School, which is now a memorial park. There is a historical marker detailing the events of the Bath School Disaster and a memorial plaque listing the names of the victims. The cupola from the original schoolhouse is still standing, often adorned with lilacs. There are remnants of the building all over the property, imbedded in the earth. And according to paranormal investigators, there are other reminders of the Bath Consolidated School there as well that often can't be seen by the naked eye.

Countless EVPs have been recorded at the park—sounds of children laughing and playing, sometimes screaming. Those who are sensitive enough to spirits to be able to see them often witness children roaming the grounds, appearing lost or confused. Sometimes the two teachers killed in the bombing, Hazel Weatherby and Blanche Harte, are seen frantically searching, presumably for their students. And there is a common belief among investigators that the wolf in sheep's clothing himself, Andrew Kehoe, still haunts the scene of his crime, preying upon the little lambs that have no idea what happened to them or that he was the one who killed them. There is a theory that he's "playing school" with them and has them all convinced that they're still alive. It's been said that whenever someone tries to communicate with the children, if anything is mentioned about the bombing or about them being dead, Kehoe's ghost shuts the conversation down and pulls the children away, convincing them the people trying to talk to them are bad. But forever prone to vanity, some investigators have had luck communicating with Kehoe and the children as long as they play Kehoe's game and pretend that the school is still standing and that he is the greatest thing since sliced bread.

While paranormal investigators often work at night, founder of Marter Paranormal Research Team Mark Briones said the site of the Bath School Disaster is most active during the daytime. "Lunchtime is when you'll get the best results," he shared. "During the time that the

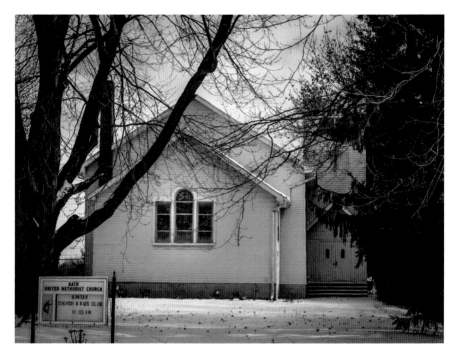

Bath United Methodist Church, which served as a makeshift morgue after the bombing. *Courtesy of Erica Cooper, 2018.*

children would have been at the school or outside playing, that's when they come out and talk to us."

And it's not just the park that's rumored to be occupied by the otherworldly. Over the years, there have been whispers that the adjacent church is haunted as well. As the body count rose in the wake of the bombing, small bodies covered in sheets lined the ground, awaiting identification. Distraught parents looking for their missing children would lift up the sheets one by one—horrified by what they saw, relieved when the body beneath the sheet wasn't their child, and then devastated when their worst fear was realized. At some point during the chaos, the decision was made to move the dead bodies into the church next door to the school so that families could have a bit more privacy while identifying their dead. Some believe that the spirits of many of those children never left the church. People have reported objects moving on their own, the sound of children's voices echoing through the chapel, and the occasional sighting of child-sized apparitions among the pews.

Nearly one hundred years have passed since Andrew Kehoe attacked the most innocent members of the Bath community, the children. If things had gone according to his plan, the entire school would have exploded rather than just the northern half of it, and the loss of life would have no doubt been much greater. His intention was to kill all of the children in the community, destroying the possibility for future generations and eventually wiping the town off the map. So perhaps there's a bit of irony in the fact that his spirit is forever trapped there now, in the town he loathed so much. Have you ever come face to face with pure evil? Take a trip to the Bath Memorial Park, and you just might.

WRONG SIDE OF THE TRACKS

East Michigan Avenue has been one of the primary roads in Lansing since the city's very early days. The capitol building marks the west end of the busy corridor, with Michigan State University bookending the east. It is home to government buildings, a world-renowned hospital, a restaurant once frequented by Al Capone and a variety of other shops and businesses. There's so much to see and do on Michigan Avenue, it's easy to miss things—like the restless spirit of a world-renowned activist that lingers near the quiet street corner on which he was murdered.

A diverse group of celebrities has hailed from the Lansing area over the years, perhaps none with more worldwide notoriety than Malcolm X. And yet, ask a room full of Lansing natives if they knew Malcolm X grew up in Lansing, and only about half of them will raise their hands. Perhaps that's because Malcolm's sad, violent time spent in Lansing shines a glaring light on a part of the city's history that many would prefer to forget. But as Shakespeare once said, "The sins of the father are to be laid upon the children." In the case of Malcolm X, this has proven to be tragically true.

An outspoken six-foot-four Baptist minister with one eye, Earl Little was not an easy man to overlook. So when he and his family moved to Lansing in 1928, people took notice. Searching for peace after a series of frightening run-ins with the Ku Klux Klan in Nebraska and Wisconsin, the Littles purchased a home on the north end of town and began saving to buy their own store. Earl gave sermons at area churches and helped spread the word of Marcus Garvey's United Negro Improvement Association,

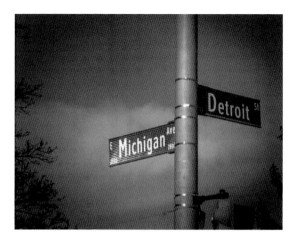

The intersection where Earl Little was killed in 1931. *Courtesy of Erica Cooper, 2018.*

while his wife, Louise, tended to their young children at home. But Earl's reputation as a troublemaker in racially oppressive communities followed him, and he soon drew the attention of a terrorist organization known as the Black Legion.

Originally from eastern Ohio, the Black Legion was a group of vigilante white supremacists formed to serve as protection for the Ku Klux Klan. To distinguish themselves from the KKK, members wore black hoods instead of white ones. The organization spread like a disease throughout the Midwest in the 1930s, with their main stronghold in Highland Park, Michigan. During the Black Legion's reign of terror, it was said to be responsible for upward of fifty murders, as well as a number of destructive fires. And once the group set its sights on Earl Little and his family, it wouldn't let them go.

In 1929, Earl found himself in a bitter land dispute with property developers who claimed that while he had the right to own his home, he did not have the right to live in it, as the neighborhood had been designated for Caucasian families only. The courts sided with the development company and ordered the Little family out of their house. But Earl wasn't ready to give up without a fight and refused to move to "a black neighborhood" as he'd been instructed to do. So the Black Legion took matters into its own hands. On one cold November night in 1929, the Littles awoke to their house ablaze, caving in around them. Earl caught sight of the two white men that he claimed set the fire and went after them with his shotgun, while Louise and the children struggled to escape the raging inferno. Rather than offer the traumatized, newly homeless family aid, police arrested Earl and charged him with the arson of his own home before quickly releasing him due to a lack of evidence. The fire was officially ruled an accident, and the

Black Legion succeeded in driving the Little family out of Lansing. The Littles spent some time in East Lansing, where blacks weren't allowed outside after dark, before buying a four-acre plot of land just south of the Lansing city limits, near what is now the MLK/Jolly intersection. Earl built a four-bedroom home with his own two hands, and the family once again began to put down roots. But on September 28, 1931, the resilient Little family would suffer a trauma from which they could not recover.

As he did a couple of times a week, Earl Little set out to collect money owed to him for chickens, rabbits and produce he and his family raised and sold as food. On this particular day, however, his wife didn't want him to go. Louise had a premonition that something awful was going to happen to her husband and tried to prevent him from leaving. But he ignored her request, resulting in a chain of events that would eventually destroy his entire family.

Louise was beside herself that day, pacing and crying as she waited for Earl to return home. Her hysteria grew as dinnertime came and went and Earl still wasn't home. In the middle of the night, the children woke up to the sound of their mother screaming and found police officers standing in their living room. Earl had suffered from what officials called a horrible accident. He was found lying across the tracks that ran down the center of Michigan Avenue, having been hit by a streetcar. One side of his head was caved in, and his body had been nearly severed in half. Malcolm was just six at the time. While the police ruled Earl's death an accident, the insurance company ruled it a suicide so that it wouldn't have to pay out Earl's insurance policy. But everyone knew the truth. It was a well known and widely accepted fact around town that the Black Legion had finally gotten its man and had gotten away with it, too.

The Littles remained in Lansing for another seven years before the pressure of raising eight children on her own became too much for Louise and she was committed to a mental institution in Kalamazoo, where she would remain for decades. The children were put into foster care and eventually moved out of the Lansing area one by one as they grew up.

But legend has it, Earl stayed behind. Over the years, people have reported seeing a very out-of-place-looking man wandering East Michigan Avenue near where the Little family patriarch was killed—tall, dark-skinned, missing an eye, wearing clothing like something out of a movie. When folks stop to ask him if he needs directions, as he often seems to be lost, he doesn't respond. Very few people know the story of Earl Little—who he was, how he died, where he died. So is it possible that the

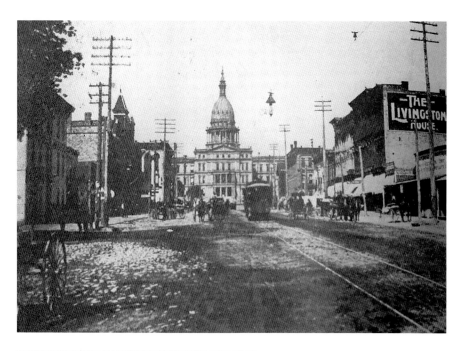

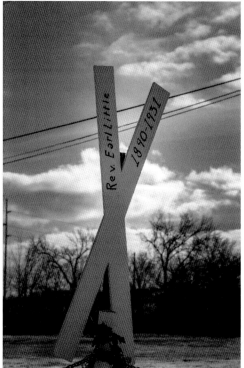

Above: The Michigan Avenue streetcar tracks of the early 1900s. *Courtesy of CADL/FPLA.*

Left: In 2017, a memorial was installed at the site of Earl Little's death by his granddaughter, Malcolm X's daughter. *Courtesy of Erica Cooper, 2018.*

appearance of a man with Earl's very distinct features in the same area where he was murdered is just a coincidence? Or is it more likely that the man standing on the wrong side of the tracks (which have long since been removed) is exactly who he appears to be? If it is Earl, what is he still doing there? Is he waiting for a streetcar that isn't coming, trying to get home to his family in time for supper? Or does Malcolm X's father stay behind to remind Lansing residents of the sins of their own fathers, sins everyone would like so desperately to forget?

Bad Medicine

On the corner of Plain and Main in Eaton Rapids, a small town southwest of Lansing, sits a stately five-thousand-square-foot Victorian abode known as Old Stimson Hospital. Once a state-of-the-art medical facility, it is currently a four-unit apartment building said to be teeming with paranormal activity. While countless deaths have occurred in the century-old building, it is the spirit of one man who is believed to be responsible for the majority of the otherworldly activity.

Built in the late 1800s, the house originally was a private residence. It was purchased in the early 1900s by nurse Harriet Chapman-Brunk, who planned to turn it into a medical facility. She enlisted two former colleagues to help her run it—fellow Eaton Rapids native Dr. Charles Stimson and Dr. Francis Blanchard, who was practicing medicine up north. Dr. Blanchard and his wife moved to Eaton Rapids at once, excited for the opportunity. But before the hospital doors even opened, tragedy struck. Dr. Blanchard's wife, Lottie, passed away from a sudden illness. His friend and colleague Dr. Stimson signed her death certificate. For the second time in his life, Dr. Blanchard found himself a widower. In 1900, he was the attending physician during the birth of his first and only child, a son, Robert. The baby died during childbirth, and his mother, Dr. Blanchard's first wife, died several days later from complications. Dr. Blanchard never got over their deaths, and though he married again, he never had more children.

Heartbroken after the loss of his second wife but determined to honor his commitment, Dr. Blanchard began taking patients when Harriet Chapman

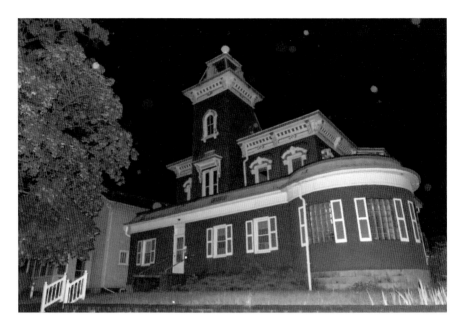

Old Stimson Hospital, Eaton Rapids. *Courtesy of Erica Cooper, 2018.*

Hospital opened in 1918. Less than six months later, on March 4, 1919, Dr. Blanchard had just finished up a surgery on the third floor and was headed back down to the main floor, where his office was. He pressed the call button for the elevator, and when the doors opened, he stepped inside, not realizing that the elevator had malfunctioned and the shaft was empty. He fell twelve feet to the concrete below, fracturing his skull. Dr. Stimson, who was working in the morgue that night, heard the crash and found his old college friend injured, but conscious. Dr. Blanchard died moments later. He was fifty-five.

Soon after Dr. Blanchard's death, the whispers began. Nurses who thought nothing of eating their lunch in the basement breakroom next door to the hospital's morgue found themselves frightened by shadows disappearing into walls and disembodied voices. Employees who spent their days confronting death were suddenly afraid of the undead. Flickering lights and doors that opened and closed on their own were seen as signs that the ghost of Dr. Blanchard was near.

During the forty years it was open, the hospital saw thousands of babies born, thousands of people treated and healed and thousands of deaths. The other two founding members of the hospital died within its halls as well. In 1930, Harriet Chapman-Brunk died from a brain tumor after a prolonged illness. The building was renamed Stimson Community Hospital after its

only remaining founding member. Then in 1943, Dr. Charles Stimson died of a sudden heart attack while treating patients at the hospital he loved so much. In 1957, the hospital shuttered its doors for good, putting an end to the death and tragedy. But the ghosts of Old Stimson Hospital continue to haunt the building to this day, especially that of Dr. Blanchard.

After the hospital closed, it was converted into a four-unit apartment building. Many families have moved in and out over the years. And many of the children who lived in the home talked often about a special friend they made there—a kind man whose name always started with a B and sounded like some variant of "Blanchard." It is thought that Dr. Blanchard's ghost is fond of children, boys especially, because he lost his own son as a baby.

While Dr. Blanchard's ghost is known to befriend children, he's not always as nice to adults on the property. Many visitors to the home report feeling uncomfortable and unsettled, as if something wants them to leave. They sometimes return home only to be plagued by nightmares, often about medical procedures or being hospitalized. Televisions change channels on their own; lights and other electronics turn themselves on and off. Doors and cupboards that residents have closed often open by themselves. Voices and footsteps are commonly heard by people alone in the building.

Dr. Blanchard is not the only spirit haunting the halls of the Old Stimson Hospital. The ghost of a child has been seen running up and down the stairs, giggling, and is known to pull people's hair on the back staircase. It is the belief of paranormal investigators that many spirits reside at the hospital and can make life difficult for tenants they don't want living in "their" home. One resident moved out just a couple of months after signing his lease. He'd heard about the building's reputation and was excited about the possibility of experiencing paranormal encounters. But liking haunted houses and living in one are two very different things. It wasn't the strange voices or the apparitions that scared him away. It was a constant atmospheric pressure that literally pushed him out of the space he was hoping to make his home.

In 1976, the third floor of the hospital, which was once the surgical ward, was destroyed by an electrical fire and is now just a crawl space. But residents often hear footsteps, voices and what sounds like gurneys being rolled from room to room coming from the third floor.

The current owners of Old Stimson Hospital are in the process of restoring it to its original beauty and hope to soon turn it into a haunted bed and breakfast. But will Dr. Blanchard and his patients welcome new visitors into their world? Only time will tell.

Fire and Ice

There is a theory among experts that when a mass casualty event occurs, the location of that event becomes a hot spot for paranormal activity. If this is true, it's no wonder that Wentworth Park along the banks of the Grand River in Lansing is rumored to be haunted. Today, the urban park is scattered with picnic tables and historical monuments. It is commonly overlooked by the busy downtown crowd despite the fact that it is the site of the greatest loss-of-life disaster in Lansing's history.

Built in 1909 on the corner of Ottawa and Grand, the Hotel Kerns was considered cutting edge for its time, the first hotel in Michigan with running ice water in all of its rooms. The exterior was brick, but the interior was hand-carved, varnished wood from top to bottom—a dream to look at, but a nightmare waiting to happen. With a boisterous bar on the first floor that guests and residents frequented nightly, a popular cafeteria that was known as a local favorite and a five-minute walk to the state capitol, the Kerns was a mainstay for politicians when they came to town.

In fact, on the night of December 10, 1934, well over half of the two hundred–plus guests staying at the Kerns were believed to be politicians in town for a conference. But as the snow fell and temperatures dropped, terror hid in the halls, lurking outside the doors of the 211 rooms at the Hotel Kerns.

As morning approached, guests awoke to the smell of burning wood and the haunting sound of people screaming. A carelessly discarded cigarette is believed to have sparked a raging inferno while hotel patrons

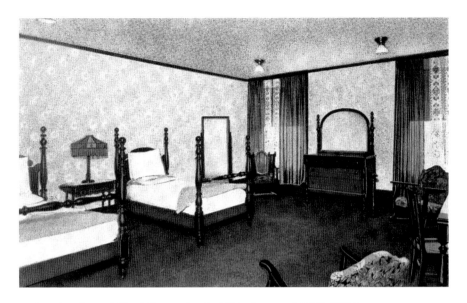

An interior photo of Hotel Kerns taken in 1924. *Courtesy of CADL/FPLA.*

slept, trapping many of them in their rooms, leaving them no chance to escape. On the north end of the building was a fire escape, but on the south end there was none, as the Kerns stood connected to another hotel, the Hotel Wentworth. Guests staying on the front end of the building were seen leaping from windows to the street below, where many of them died instantly. But those staying on the east side of the building faced an even worse dilemma. Unable to reach the stairs or the fire escape, they had two choices—they could wait for help and take the risk that the fire would reach them before rescuers would, or they could jump from their windows to the icy Grand River below, on a morning where it was one degree above zero outside and there were two inches of snow on the ground. While many of the guests died by fire waiting for one of just four fire ladders on scene to reach them, others chose ice and were seen hitting the water, never to resurface.

As the sun rose and revealed the true horror of the Hotel Kerns fire, first responders tirelessly labored in the frigid cold to keep the blaze from reaching the adjoining Hotel Wentworth, which was also packed with guests. One of the first firefighters on the scene was struck by a falling body in the early moments of the fire. He worked for eight hours before he allowed colleagues to take him to the hospital, where it was discovered that he had a broken back.

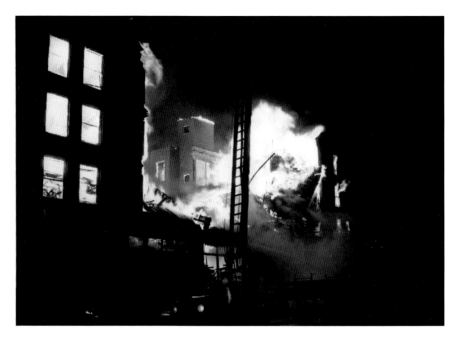

The Hotel Kerns ablaze, December 10, 1934. *Courtesy of CADL/FPLA.*

Initial news reports speculated that upward of one hundred people had died in the blaze, which would have been just about half of the guests staying in the hotel that night. But as the day went on and those who escaped began resurfacing at local hospitals and neighboring hotels, the death count dwindled. In all, thirty-four people died in the Hotel Kerns fire, including seven state legislators—some by fire, some by ice. Forty-four more were injured, fourteen firefighters among them, making it the worst loss-of-life disaster in Lansing history to date and one of the deadliest hotel fires in U.S. history.

According to Christine Peaphon of Mid-Michigan Paranormal Researchers, the site of the Hotel Kerns fire is a perfect example of a residual haunting. A residual haunting is essentially a recording of a tragic event from the past that plays like a movie over and over throughout time. Peaphon, a psychic/medium, visited the site of the hotel fire without any knowledge of what had occurred there and could see people jumping into the street, as well as others walking the water line, as if searching for something in the river. The entities were unaware of and unaffected by her presence, as is typically the case with a residual haunting. Many visitors to the park, guests of the neighboring hotel, and even just passersby have

reported similar experiences—seeing ghostly men and women roaming the grounds of the park, forever lost.

And it's not just the park itself that is rumored to be haunted. The building adjacent to Wentworth Park has been plagued with strange goings-on since it was built in 1937, just three years after the fire. Now known as the Accident Fund Building, the former power plant is said to be home to dozens of "burned souls," assumed victims of the Hotel Kerns fire. Lights in the building are known to turn on and off by themselves, and full-bodied apparitions have been spotted throughout the renovated office space over the years. One night, the janitorial crew was preparing to clean the women's restroom on the sixth floor when they heard someone cough on the other side of the door, followed by running water. The crew waited several minutes for whoever was in the bathroom to come out. When no one did, they opened the door, only to find that the restroom had been empty the whole time. Once, an employee was alone in a secure room in the middle of the night, with no windows or doors open, when a strong, floral-scented breeze cascaded through just as a shadow crossed the opposite side of the room. While the story of the Hotel Kerns fire is not well known in Lansing, the haunting of the Accident Fund Building is widely talked about among employees.

If the scene of a tragic event can hold a residual haunting, what about a remnant from a tragic event? Many paranormal investigators believe that a physical object can hold residual spiritual energy, much the same way a physical location can. This theory could provide another explanation for the spirits that haunt Wentworth Park. While the greatest loss-of-life disaster in Lansing's history has been largely forgotten over time, the deadliest event in modern American history never will be.

Located mere feet from the Hotel Kerns historical marker is what, at first glance, appears to be a large, abstract sculpture. But it is so much more than that. It is Lansing's 9/11 Remembrance Memorial—a tall, mangled fragment of an I-beam from the World Trade Center wreckage that twists into the sky, illuminated by spotlights at night. How much of the paranormal activity at Wentworth Park can be attributed to that sliver of the World Trade Center and whatever spirits might be attached to it? And how ironic is it that the 9/11 Remembrance Memorial was given a home on the site of a tragedy that, while much smaller in scale, was very similar in terms of the fates suffered by victims and first responders?

Whether or not you believe in the paranormal, a trip to Wentworth Park to visit the site of the Hotel Kerns fire and the 9/11 Remembrance Memorial is certainly a haunting experience.

From the Depths

If horror movies have taught us anything, it's to be wary of bodies of water, especially at night. Sea monsters, dead bodies come back to life, deranged killers—who knows what's hiding in the murky depths? Mid-Michigan is home to hundreds of lakes and rivers, and while many of them have their own ghost stories and urban legends, the history of Lake Lansing is the stuff true tales of the paranormal are made of. Native American curses, séances, organized crime, abandoned amusement parks—the thirty-acre lake has seen it all. And many believe that the ghosts of Lake Lansing's storied past remain today.

The area now known as Lake Lansing was first discovered by European settlers in the mid-1800s, but before that, it was home to several different Native American tribes who lived among the glorious white pines that surrounded the lake and fished in its crystal clear waters. It was their belief that the area was a natural resource for all to utilize, and their people were able to flourish on the land for many years. But when the U.S. government sold the land to European settlers in 1836, the public property became private and was given the name Pine Lake. The Native Americans were forced from their land, and were said to have cursed the lake itself when they left. The majestic white pines were butchered, houses and cabins were built in their place and the lake became overrun with tourists. Rumors persisted that the land was cursed, but wealthy locals set on owning lakefront property didn't pay them much mind.

In the 1880s, a twenty-acre spiritual camp was built on the shores of Pine Lake, later renamed Lake Lansing. Psychics and mediums from all over the country visited the commune, which had a séance hall and a medium house that could only be entered by mediums. The rituals held at the spiritualist camp were shrouded in secrecy, with many locals concerned that campers dabbled in the dark arts. Like other establishments that would come to Lake Lansing in the decades to follow, the spiritualist camp failed and was eventually abandoned, just as a new evil came to town.

In the late 1800s, two new establishments were built on the lake: the Pine Lake House and the Izzer Club. Pine Lake House was a resort hotel complete with a casino and dance hall, while the Izzer Club was a men's social club built on pylons in the middle of the lake, where all sorts of unsavory business was said to occur. With a trap door in the floor and a lookout on shore to alert club-goers of incoming sheriff's raids, the Izzer Club became very popular during the Prohibition era. The only way to the club was by boat, so whenever the law showed up, there was plenty of time to dump liquor, weapons and anything (or anyone) else that needed hiding through the trap door, into to the depths of the lake.

Because of the venue's unique ability to protect and cultivate criminal activity, famed mobsters Al Capone and Mickey Cohen were said to frequent the Izzer Club in the 1920s. Rumors abound that in addition to bootlegged liquor and illegal weapons, many a rival gang member took a trip through the Izzer Club's famed trap door, never to resurface. Mickey Cohen was

Haslett Park Spiritualist Camp, circa 1910. *Courtesy of CADL/FPLA.*

Ferries carrying guests to the Izzer Club in the middle of Lake Lansing (then called Pine Lake) in 1911. *Courtesy of CADL/FPLA.*

known to be a frequent guest at the Pine Lake House, which mysteriously burned down in 1929 and was replaced by a night club called the Dells Ballroom.

Over time, the ballroom was torn down and turned into condos, while the Izzer Club was demolished. The spiritualist camp was turned into an amusement park in an attempt to keep tourists coming to the area, but that was abandoned eventually as well. Centuries worth of intriguing history, gone without a trace. Not even the lake remained the same. Its name was changed to Lake Lansing in 1929, and its crystal clear waters became heavily polluted. Every time a business built on Lake Lansing failed or the water reached toxic levels, whispers of the ancient Native American curse resurfaced. If the lake wouldn't be used for its intended purpose—a natural resource for everyone—it couldn't be used for commercial purposes, either, and any business that attempted to open there was doomed to fail.

There are darker tales about Lake Lansing, as well. Rumors persist that the land itself has been known to drive people mad. In the early days of the Lake Lansing Amusement Park, it is said that a mother took her young child on the park's most popular ride, a wooden roller coaster. When they reached

the top of the ride's biggest drop, she tossed her toddler from the car to the ground below, killing the child instantly. Some claim that the cries of a young child have been heard throughout the park ever since.

More recently, the strange life and death of a man by the name of Steven Rigby came to light due to a land dispute between the county and Rigby's relatives. Rigby lived in a small house that was built by his grandfather on the lakefront in the 1940s. While the house itself was little more than a shack, the value was in the land the house was built on, which came to be worth hundreds of thousands of dollars over the years. Rigby inherited the property when his father passed away in 2001. A longtime recluse, Rigby was not close to his family and never married or had children. He was well known around the neighborhood as a loose cannon who could hold a pleasant conversation one day, then fly into a rage for seemingly no reason the next. Rigby's odd behavior continued right up until his death in 2012. He told neighbors that he was headed out of town, then disappeared from sight. Several weeks later, his overgrown lawn and the pained cries of his beloved cats prompted neighbors to call authorities. Police stumbled upon a grisly scene when they entered Rigby's home. His corpse had been decomposing for nearly five weeks following an apparent suicide. Neighbors believe his impending foreclosure due to delinquent property taxes prompted Rigby to take his own life. For five years, distant relatives of Steven Rigby battled Ingham County for the rights to the property. In 2017, the Michigan Supreme Court ruled in the county's favor, and the Rigby homestead was sold at auction. But some locals believe that while Rigby's family lost their claim to the land, Steven will never give up his home, and his spirit haunts the property to this day.

Today, there are two public parks located on Lake Lansing. Lake Lansing Park North, near where the Pine Lake House and Dells Ballroom once stood, has a small boat launch on the lake, with the majority of its amenities across the road from the lake itself. Lake Lansing Park South, the former home of the spiritualist camp and amusement park, is now a popular beach complete with a playground and picnic area. Both parks close at dusk, and the remainder of the lakefront is private property—lined with both year-round homes and summer cottages. This makes a late-night trip to Lake Lansing virtually impossible, which is probably for the best, considering that a Native American curse, portals left open during spiritualist séances, the victims of mob violence and residents gone mad are said to plague the land. Many people have reported feeling an eerie presence on the lake, seeing faces in the water that aren't there and hearing

voices that belong to no one. A popular destination for locals and tourists alike, it can be difficult to find a quiet moment at Lake Lansing, which makes it all too easy for modern society to drown out the voices calling out from the depths. But if legend is to be believed, just because we can't hear them doesn't mean they're not there.

A Lesson in Evil

The city of Portland, just northwest of Lansing, is a small community with big history. The picturesque City of Two Rivers was the final resting place of the great Chief Okemos, who died there in 1858. His modest grave can be found on the banks of the Grand River. Ghost stories about Chief Okemos haunting the woods surrounding his burial site have plagued Portland for over one hundred years. But it is another ghost, one with a sinister past, that residents are most afraid of. In the heart of town is a century-old former school known as Old School Manor; locals claim it is haunted by the spirits of those who died there.

Portland's first high school was built in 1881 on the property where Old School Manor now stands. As the story goes, a young girl was killed in a tragic accident due to the negligence of the school's janitor. She was crushed by the aging bleachers in the gymnasium after the janitor, who'd been tasked with repairing them, failed to do his job. In his grief, the girl's father murdered the janitor in the school and then burned the building to the ground to hide his crime. The janitor's tortured soul is said to remain on the property to this day, terrorizing visitors.

If this sounds vaguely reminiscent of Freddy Krueger's backstory, that's because it is. But the original high school building did burn down in 1918. Old School Manor was built in its place and opened in 1920. Rumors of a haunting began almost immediately. People claimed to see the ghost of the little girl in the windows at night when the building was closed and no one was inside. The janitor, Henry, was said to chase students through the halls

when he caught them alone and was responsible for the nightmares of many children over the years.

The school closed in 1991 and was converted into an apartment building. Residents often reported an eerie feeling in the halls at night, like they were being watched. Doors would slam on their own, phantom telephones would ring out in the common hallways and people have claimed to hear knocking on their walls and doors, with no one on the other side. Items inside apartments would be moved, often thrown onto the floor and left for frightened residents to find. Recess bells remained attached to the wall on each floor and, although they had been disconnected for years, would often ring out in the middle of the night, sending residents running outside thinking a fire alarm had been triggered. Several children who lived in the building over the years made friends with an imaginary entity named Henry, who is believed to be the spirit of the janitor. One particularly spooky spot in the building is the school's old boiler room, where Henry the janitor was supposedly murdered.

In 2008, Old School Manor was condemned and closed to the public. But the ghost stories only worsened once the imposing Collegiate Gothic–style building was abandoned. Many a thrill-seeker has broken into the building late at night to explore, only to be chased out by someone…or something.

The building was later sold and underwent years of improvements and renovations. All twenty-nine apartments were completely rehabbed to be made more modern, while still keeping the building's vintage charm. Residents say it kept something else, as well. They say the ghost of Henry the janitor is still there. And he is not a fan of company.

Medium Cat Ryan once visited Old School Manor, and while she didn't sense the presence of the little ghost girl or Henry the janitor, she picked up on something much more malevolent. She had just recently joined the Michigan Area Paranormal Society and was on an investigation at a private residence in Portland. While she discovered several spirits in the home, she sensed that they were coming from elsewhere and set out with another medium to explore the neighborhood.

It didn't take long for them to find the source of evil. Negative energy was emanating from the then abandoned Old School Manor in waves. Just touching the building left both women feeling ill. They saw several shadow people in the windows and even caught a glimpse of the Hat Man.

According to urban legend, the Hat Man is a malevolent shadow person that often appears to people in their sleep. He has been the stuff of

nightmares since as far back as the 1500s. Those who see him are said to feel extreme terror, which he then feeds off of, often driving people to suicide.

Unnerved by the encounter at Old School Manor, Ryan quickly left the condemned building, hopeful that it would soon be torn down. "Very, very little scares me, and I was shocked when I found out people were living in that building again," she said.

Old School Manor, now Portland School Apartments, boasts twenty-nine affordable, energy-efficient living spaces for residents to choose from. But does it offer something else, also? If the legends of Henry the janitor and the Hat Man are to be believed, it very well just might.

CITY OF FIRE

Surrounding the city of Lansing are dozens of small agricultural communities, many with their own storied histories. But perhaps none have a past quite as peculiar as that of the village of Dansville. Dansville is a farming town with a population of right around five hundred. Downtown consists of a grocery store, a restaurant, a gas station, a library and not much else. It is also the home of an unprecedented amount of paranormal activity, making it a point of interest for paranormal investigators from all across the country. While most people know Dansville as the scene of an infamous fire in the 1970s, the town's history with fire goes back hundreds of years.

Dansville was a much different place in the 1800s. It was bustling with activity and had two hotels, a theater and a host of shops and restaurants. It was one of the more established cities in Ingham County until a raging inferno destroyed much of the downtown area on August 29, 1889. While no fatalities were reported, the heart of the city was decimated, and the small town struggled to rebuild. Many of the businesses did reopen over time, and Dansville returned to its heyday. And then, just fourteen years after the first fire, another great fire ripped through the downtown area in 1903 and leveled many of the businesses again. This time, fewer of the buildings were rebuilt. So when fire once again came to downtown Dansville in 1937, fewer buildings were destroyed. Ten years later, a massive fire turned Dansville's Town Hall and library to ashes, taking many of the town's historical artifacts with it. And fire wasn't done with Dansville yet. The first fire-related fatality didn't occur until 1977, in a

Dansville is located just south of Lansing. *Courtesy of Erica Cooper, 2018.*

crime so scandalous it sent shockwaves across the nation and became a bestselling book and cult-classic movie.

On March 9, 1977, the residents of Dansville awoke to a horrifying scene: the small house on Grove Street where a young family of six lived was engulfed in flames. Mickey and Francine Hughes, along with their four children, were feared dead, as firefighters couldn't get anywhere near the house to check for survivors. Mickey's family watched in agony; his mother, Flossie, his father, Berlin, and his brother Donavon just happened to live next door and were on scene before first responders arrived. Rescue workers had to hold them back as they screamed and fought, trying to get into the house to save their loved ones. Once the fire died down and firefighters were able to get inside, they found only one body—that of Mickey Hughes. Francine and the kids were safe in the custody of the Ingham County Sheriff's Department, and the story she was telling them was one the entire country would soon know by heart.

Francine and Mickey married young. She was sixteen; he was eighteen. He and his brothers were known as the bad boys around town. Mickey had

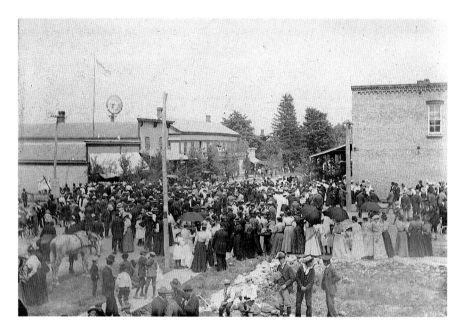

Downtown Dansville following the 1889 fire that destroyed much of the town, with the Union Hotel in the upper left of the photo. *Courtesy of Dansville, Michigan Historical Society.*

a nice car, and he made Francine feel like a princess. They got married quickly and moved in with Mickey's parents. Francine thought she'd found her knight in shining armor. But Mickey Hughes very quickly turned into her greatest nightmare. He was controlling, manipulative and, before long, began physically abusing her. Mickey's parents, who were said to have an abusive relationship of their own, made no attempt to help the frightened young girl as she hid in closets and under beds to get away from Mickey when he flew into his rages. Things got so bad, Francine fled to her mother's house in Jackson, about a half hour from Dansville. Also a victim of domestic abuse, Francine's mother had little sympathy for her and promptly sent her home to Mickey. The police were called to the Hughes home many times over the years, but as they never actually witnessed Mickey abusing Francine, there was nothing they could do.

For over a decade, Francine endured brutal beatings at the hands of the man who was supposed to love and protect her. During that time, the couple had four children. While Mickey was not abusive toward the children, he never hesitated to beat their mother in front of them. They moved around a lot. Mickey couldn't hold a job due to his substance abuse issues, and they were very poor.

Eventually, Francine filed for divorce. Her children were starving, and she needed welfare benefits, which she would only qualify for as a single mother. She moved out, got a grant for school, started taking college courses at Lansing Community College and was determined to better her life and the lives of her children. Once Francine left him, Mickey's life went even further off the rails. He began drinking very heavily and was involved in a near-fatal accident as a result. In a coma, suffering from a traumatic brain injury, doctors said that if Mickey lived, he would never fully recover. He lived. And after over a month in the hospital, he was sent home to live with his parents.

For some reason that was never quite understood, Francine felt a sense of duty to help take care of Mickey. She rented the vacant house next door to Berlin and Flossie's place so that she could be nearby to help and so that the children could be near their father. But Mickey recovered soon enough, and with Francine so close, it was easy for him to slip into old habits. He essentially moved into Francine's house and refused to leave. He acted as though she was still his wife, even though they were divorced. The emotional and physical abuse resumed and, some say, got worse.

On March 9, 1977, Francine suffered an especially brutal beating at the hands of her ex-husband. She called the police, who were no strangers to the Hughes family. Even though they found Francine bruised and bloodied, even though they heard Mickey threaten to kill her and even though he threatened to kill one of the officers on scene, police failed to arrest Mickey—a decision that would come to haunt the entire town for decades.

That night, though she was still wounded from the earlier beating, Mickey attacked Francine again. He took her out behind the house and made her burn her schoolbooks, promising she would never go back to college. He forced himself on her. And then he passed out drunk in her bed. Later, Francine would describe the decision she made next as one of the most rational things she'd ever done. She rounded up her frightened children and told them to put their coats on and wait for her in the car. She went out to the garage and got a gas can, then proceeded to pour gasoline all around the bed where Mickey slept. She lit a match, tossed it to the ground, and as she drove away from her house of horrors, it exploded into flames.

Francine Hughes's trial received national attention, as it thrust domestic violence into the spotlight. She was found not guilty of murder by reason of temporary insanity. Her case inspired a book titled *The Burning Bed* and a made-for-TV movie of the same name starring Farrah Fawcett as Francine Hughes. It also inspired changes in domestic violence laws and brought the first women's shelter to Ingham County. Francine left Dansville with her

children once her trial was over and eventually moved out of state. She got her nursing degree and lived a quiet life of anonymity down south as a mother and grandmother until her death in 2017.

But some say Mickey never left Dansville, that his ghost still haunts the property of his former home. They say that if you visit late at night, you can hear the sound of a man's tortured screams. Whether or not he haunts the location where he died, Mickey's spirit undoubtedly haunted his family, who lived just next door. Two years after Mickey's death, his brother Donavon committed suicide, unable to cope with his grief. Two years after *The Burning Bed* movie came out, Mickey's father committed suicide in the family home.

Medium Cat Ryan has visited the site of the Hughes homes on several occasions and believes there is an overwhelmingly strong male presence there—one that is very angry and has much hostility toward women. Given that three members of the same family lived violent lives and died violent deaths on the same property, it makes sense. While the home Mickey Hughes died in is long gone, the house he and his brother grew

The former Hughes home in Dansville. *Courtesy of Erica Cooper, 2018.*

up in, where much of the violence against Francine took place and where Berlin Hughes committed suicide, still stands today. And whether or not the spirits of the Hughes men remain, the memory of *The Burning Bed* continues to haunt the town.

While the fire that killed Mickey Hughes is certainly the most well-known fire in Dansville, it was not the last. In 2011, the lone bar and restaurant in town, the Wooden Nickel, burned down in the middle of the night. It was rebuilt a bit farther back on the property, and the residents of Dansville are holding their collective breath in hopes that the 2011 fire was the last.

But why have destructive fires been such a common occurrence in Dansville? Is the town cursed? Or is it haunted by a madman whose blood flows beneath the city?

The first hotel to open in Dansville was the Union Hotel, built in 1858. In 1879, the hotel came under the ownership of a man named Thedro Owen, who traded his farm in nearby Bunker Hill for the property. Owen, a married father of three sons, immediately regretted the decision. He was not a well man. A year prior to taking ownership of the hotel, he'd been a patient at the Michigan Asylum for the Insane for several months before being declared cured and released back into the real world. Determined never to return to the dreadful asylum, Owen hid his mental illness from friends and family and attempted to lead a normal life, even making such a bold choice as to trade his farm for a hotel. But the change proved to be too much for him, as he was heard several times saying that he wished to be back on his farm. Solitude and hard work suited him. The chaos of running a busy hotel did not. After a few months, Owen was no longer able to hide the toll that running a hotel was taking on him. Those around him knew something was off, but on his final day on earth, he seemed to be feeling better.

On September 18, 1879, Thedro Owen told his family he was going to go to bed early, as he'd not slept well the night before. He turned in around 7:00 p.m., then got up a short time later and left the house. He walked down the street to the post office, then back to the hotel, where he was seen headed toward the rear of the building. A short time later, Owen's son found his father's hat and lantern lying beside the cistern beneath the hotel, along with an alarming amount of blood. The cover of the cistern had been removed, so Owen's son jumped in, hoping to save his father. He landed in roughly five feet of water, stained crimson by his father's blood. He pulled his father from the cistern, but it was too late to save him. Thedro Owen's head had been nearly severed from his body by his own hand. Investigators would later determine that Owen first attempted

suicide in the icehouse behind the hotel, as a sickening amount of blood was found there. Using a razor, he sliced his own throat from ear to ear. When he did not die instantly, he used a clothesline to support himself as he stumbled to the cistern, where he removed the cover, took off his hat and slashed his throat several more times before falling headfirst into the water below. Nearly ten years to the day after Thedro Owen went mad and poisoned the city's water supply with his own blood, the fires in Dansville began. Is it possible that he is on a quest to destroy the town he believes robbed him of his sanity and ultimately cost him his life? Or is there another explanation?

Because of the fires, there aren't many historical buildings left in downtown Dansville. But one of the town's most notable structures, the Octagon House, has been standing tall since 1863, when it was built by pioneer physician Dr. D.J. Weston. The eight-sided, two-story architectural oddity has twelve rooms, a basement with a false bottom and a cupola that once served as a lookout. There are speaking tubes throughout the house that extend to the cupola, trap doors in the floors and long-collapsed tunnels that run under the house. Some say the tunnels once extended all the way to Lansing. But why such a strange structure with such strange features in what has turned out to be quite a strange little town? It's rumored

The Octagon House in Dansville. *Courtesy of Erica Cooper, 2018.*

that the Octagon House was once a stop on the Underground Railroad, a network of secret routes and safe houses used to help nineteenth-century slaves escape to freedom in the north. Runaway slaves would hide out in the basement, sometimes for weeks, until it was safe to travel to their next destination. It's said that a number of slaves died in the house from illness, injury and poor conditions before they could escape. Out of fear of getting caught, it's more likely than not that their bodies would have been buried under the house rather than transported to another location. Over the years, it's been rumored that the now vacant Octagon House is haunted by the spirits of trapped slaves: a lantern often flashes from the boarded-up cupola, the sound of banging on windows and walls from people desperately trying to escape can be heard late at night and the shadows of forgotten slaves pass by the windows from time to time.

Could it be that the town is haunted by the tortured souls of lost slaves buried beneath it? Or is the ghost of Thedro Owen to blame? Or is the village of Dansville haunted by another evil altogether? Take a visit sometime and decide for yourself.

The Legend of Seven Gables

Just south of Dansville's main intersection is Seven Gables Road. At first glance, it is no different than any other country road. But as houses give way to a tunnel of trees and an eerie quiet, one's heart begins to quicken, and there is no mistaking that you are on the most haunted road in Michigan. At the end of the dirt road you will find a red wrought-iron gate, padlocked to keep vehicles from entering. But beyond that gate, traversable only by foot, are five thousand acres of state game land—wild terrain overrun by coyotes and rattlesnakes and, some say, an evil presence that can't be explained.

Every small town has its own urban legend, a story passed down over generations that changes a bit each time it's told. The Legend of Seven Gables is Dansville's. As the story goes, a witch once lived in a stone cottage at the end of Seven Gables Road, and one night, a band of marauders passing through decided to burn the witch alive. So they sealed all of her windows and doors, then set her house ablaze. Before she died, she cursed the land, making it uninhabitable for future generations. Furthermore, she proclaimed that whenever a scream was heard in the forest, the last person to make it back over the gate on their way out of the woods would be dead within three days. The legend goes on to say that many years later, a family built a house on the land. Within weeks, the father began to go mad. His behavior became increasingly erratic, until one night he killed his wife and children and hung them from the seven gables of the house before burning it to the ground and hanging himself in a nearby tree. There is, of course, no

Seven Gables Road in Dansville. *Courtesy of Erica Cooper, 2018.*

truth to either of these stories, but they're fun to tell on a moonless night in the dark silence of the Seven Gables woods. There was a farmhouse on the property, but no one is known to have died there and certainly not in any sort of glorious fashion. There is a debate over whether the house was burned to the ground purposely as a means of demolishing it or unintentionally (which would not be out of the ordinary for Dansville). Either way, the house is long gone. If you know where to look, you might be able to find the remnants of the foundation. But be careful, because you might just find something else as well. The lack of a good backstory doesn't mean that the rumors about Seven Gables being haunted are untrue.

On any given night, the small circular drive at the end of Seven Gables Road is filled with cars—curious thrill seekers, paranormal investigators, hunters. Odds are, if you visit Seven Gables, you will find that you're not alone out there, in the most literal of senses. But there's not always safety in numbers, and the ghosts of Seven Gables certainly aren't afraid of crowds.

I have been to the majority of the locations in this book, some of them many times. And out of all of them, Seven Gables is the one spot I never look forward to visiting. There has not been a single time that I've been there that something strange hasn't happened, be it having my hair pulled

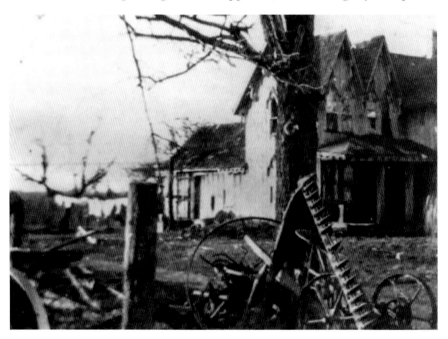

The Whitney farm, once located at the end of Seven Gables Road, early 1900s. *Courtesy of Michigan Area Paranormal Society.*

when there's no one around, being pinched by an invisible entity, catching a full-body apparition on video, hearing footsteps beside me when I'm alone, feeling as though I'm being watched through the trees, or just an overall sense of extreme discomfort and unease. And those are just the paranormal things that have occurred. I've been stalked by a pack of howling coyotes, found dozens of pentagrams carved into the ground, accidentally leaned up against the gate only to find it covered in blood (hopefully of the animal variety). The list is endless. And when I tally it all up, it equals out to Seven Gables being a place where I simply do not enjoy being. But is it actually haunted? From my experience, I would say yes.

According to Christine Peaphon of Mid-Michigan Paranormal Researchers, there are some very old spirits at Seven Gables, possibly Native Americans. While she did not sense evil, she did sense an overwhelming presence of old magic on the property. Keith Daniel is the founder of Michigan State Paranormal Investigations. On his first visit to Seven Gables, he was unaware of the area's reputation. He was there on a hunting trip, and found himself unable to focus, as he felt that someone was watching him the entire time he was there. When he learned that Seven Gables is said to be one of the most haunted places in Mid-Michigan, it all made sense. He has since been back on several investigations and has no doubt that the land is haunted.

One local recounted a time that she visited Seven Gables at night with a group of friends. They drove slowly down the road in overwhelming darkness, as far as the wilderness would allow. When the driver backed up to turn the car around, her passengers in the backseat turned white with fright. The driver followed their gaze and was shocked to see that standing in front of her car, in plain view of the headlights' beams, was a little girl in a long, white nightgown. The girl did not speak, did not move. Nor did anyone in the car. After what felt like several minutes, panic overtook the driver, and she knew she had to get out of there. But the little girl was directly in her path, and there was no way around her. It was evident to everyone in the car that the little girl was not an actual, living child. So the driver slowly inched forward until her car was nearly touching the little ghost girl, who simply vanished into thin air.

It is common to feel invisible eyes on you at Seven Gables, be it daytime or in the dead of night. People often hear growling that seems to have no source, footsteps that belong to no one and the sound of children crying. There are reports of shadow people, full-bodied apparitions and orbs dancing among the trees. Every once in a while, someone will hear the

dreaded shriek that the witch's curse warns of. But so far, there have been no reports of anyone dying after visiting Seven Gables.

The terrain is rough, the wildlife is dangerous and the spirits are restless. But the true horror of Seven Gables lies in its connection to the murders of two local children, thirty-five years apart.

The Murninghan family was well known in the Lansing area in the 1960s. Max Murninghan served as mayor of Lansing from 1965 to 1969, and his wife and children were very active in the community. His daughter Laurie worked at a gift shop just a few blocks from their home on the west side of Lansing. On the afternoon of July 9, 1970, Laurie was working at Gallagher's Gifts and Antiques with the store's owner, Mrs. Gallagher, when a soft-spoken man in his late twenties entered the store and asked for change for a twenty-dollar bill. When Laurie told him she was unable to make change, the man pulled a gun and began to struggle with Mrs. Gallagher. He struck Mrs. Gallagher in the head with the gun, which fired into the ceiling. When she hit the ground unconscious, the man thought he'd shot her, so he grabbed the only witness, Laurie, and fled the store. It was broad daylight and the shop was located near one of the busiest intersections in town, but no one saw the tall stranger drag Laurie down the street and force her into his car. And no one would ever see Laurie alive again. Despite the fact that the FBI became involved almost immediately—launching the largest manhunt in its history up to that date—and despite the fact that Laurie's father, the beloved Mayor Murninghan, took up vigil at the police station, there were no leads in Laurie's case. And then on July 20, nearly two weeks after Laurie's disappearance, two young boys searching for soda bottles along the road found Laurie's body in a marsh on the same state game land that is part of Seven Gables. Her killer was never found, and her murder is one of the oldest cold cases in Lansing.

Thirty-five years after Laurie Murninghan's death, a seven-year-old boy disappeared from his home in the town of Williamston over the Fourth of July weekend. Investigators led an exhaustive search for Ricky Holland, whose adoptive parents insisted he had run away from home. The entire community joined the search, thus becoming invested in little Ricky's fate. As summer turned to fall and fall turned to winter, the hope that Ricky would be found alive faded. While the public had no idea what happened to the sweet little boy they'd all worked so hard to find, detectives believed they knew who was to blame. All they needed was proof. Six months after Ricky's disappearance, with the walls closing in on them, Ricky Holland's adoptive parents turned on each other, each blaming the other for Ricky's

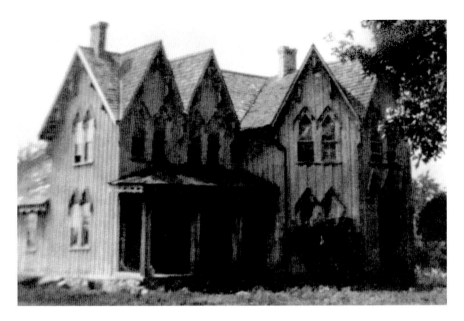

The Seven Gables House in the early 1900s. *Courtesy of Michigan Area Paranormal Society.*

death. Investigators would later determine that Ricky's adoptive mother, Lisa Holland, murdered the child, while her husband, Tim, disposed of the body. On January 27, 2006, Tim Holland led police to the body of Ricky Holland. Senior officials on the scene knew the area well. Ricky's body was dumped less than a mile from where Laurie Murninghan's body had been found decades earlier.

There are countless stories about the haunting of Seven Gables Road, many of them involving children. And there are several different urban legends offered up as an explanation for the paranormal activity. But as is usually the case, the truth about Seven Gables and the state game land it's attached to is much more horrifying than any ghost story.

An Ancient Evil

Purchasing a new home is a labor of love. When you take out a mortgage that spans decades and spend years renovating a house and making it your own, it becomes a part of you—your family's future, your personal legacy. So what do you do when things begin to go horribly, terrifyingly wrong? Do you pull up your roots and start over? Or do you hunker down and fight for what's yours?

When one local family purchased a home in Leslie, a small town south of Lansing, they were looking forward to a new beginning. But as they poured their hearts and souls into turning it into their dream home, they began to notice the toll the house was taking on not just their hearts and their souls but their minds and bodies as well.

It all started innocently enough—members of the family began seeing shadows in the halls and hearing footsteps on the stairs. The family's teenage daughter began seeing a dark figure in her room at night, so she would shut and lock her door, only to wake up to the sound of her doorknob rattling and shaking, as if someone (or something) was trying to get in. Her mother began to have nightmares and would wake up with her heart racing. They both began suffering from debilitating headaches.

And then the physical harm began. Both women started finding unexplainable scratches and bruises on their bodies. Following her nightmares, the mother would often wake up with fingerprint-shaped bruises on her thighs. One afternoon, father and son were out in the barn working on a project when the father set his circular saw down on the ground for a

moment. He turned toward his son to say something to him, and noticed that his face was stark white, his eyes wide. He turned back around to see the circular saw levitating in the air before falling directly on his foot, severing three of his toes. Countless contractors hired to work on the house became the victims of freak accidents as well.

Worse than the physical threat to the family was the toll living in the house began to take on their mental states. All of the family members felt a dark, heavy presence in the home. When they were outside the house, they would report being in good spirits. But the instant they walked through the door, it was like a switch flipped. They would instantly feel angry, depressed and start fighting among themselves. It didn't take them long to figure out that the house was causing these mood swings. Their house was, quite literally, driving them crazy. As they would come to find out, they weren't the first people this happened to.

The original owners of the property were the Peek brothers, Lafayette and Theodore. They purchased the land in the 1860s to build an apple orchard on, and each lived there with their families. Lafayette and his wife, Harriet, lost all three of their children before the age of one. Theodore and his wife, Sarah, lost three of their four children as well, which eventually drove Theodore to a mental breakdown. He was often seen wandering the streets of Leslie, screaming, crying and talking to himself. Things got so bad that his daughter attempted to have him committed to an insane asylum.

After the Peek family came an awful man by the name of John Stitt. He and his wife, Maria, lived in the home with their only daughter in the 1880s. John was known around town as a serial adulterer, and after twenty years of marriage, his wife filed for divorce in 1887. That same year, Stitt's next-door neighbor Elbert Blackmoor sued John Stitt for alienating his wife Elizabeth's affections. Stitt and Blackmoor settled out of court, the Blackmoors got divorced and John Stitt married Elizabeth Blackmoor. Elizabeth Blackmoor moved into John Stitt's home with him along with her fourteen-year-old adopted daughter, an African American girl by the name of Etta Meekins. Before long, it was rumored that Stitt was having an affair with his teenaged stepdaughter. In 1902, Elizabeth died under mysterious circumstances. Her sixty-four-year-old philandering husband died just a few weeks later. His body was found in the bed of his stepdaughter, Etta Meekins. And in his will, which had just recently been changed, he left everything to Etta and nothing to his biological daughter from his first marriage. People around town speculated that John had gone crazy or that Etta had bewitched him.

Aside from the Peeks and the Stitts, there were reports of many of their neighbors suffering similar fates. It seemed that a high percentage of people living in that area suffered mental breakdowns or were diagnosed with emotional disorders. Many of them were relegated to insane asylums. What was it about the land that drove people crazy?

Desperate to answer that question, the family under attack by what they believed was an evil entity sought help. They brought in expert investigators from a popular TV show in a last-ditch attempt to save their home and their sanity, but the results of the investigation were less than comforting. According to a world-renowned psychic and paranormal investigator, there was an ancient evil living on the property, one that had been there since long before any humans. Not a human entity or even a demon, this presence was classified as a devil, the very worst kind of spirit, and its goal was simply to torment the living and make them go insane. Its primary focus was the women in the home. The men were being tortured by another spirit altogether, one the psychic referred to as "the creeper." This was a human spirit, possibly someone from the family's past, and he was focused on trying to get the men in the home to harm themselves and commit suicide, which was how he died. In addition to the devil and the creeper, the psychic believed there were up to fifty spirits in the basement, possibly former residents of the house and/or the land.

While this information would be enough to cause many people to flee their home with little more than the clothing on their backs, the family decided to stay. They were given advice on how to rid their house of the evil spirits that had all but taken over. While things were believed to have calmed down initially, the attention from being featured on TV seemed to feed the evil entities on the property, and the paranormal activity actually increased. The family still lives in the home to this day but reportedly refuses to talk about their experiences, for fear of making things worse. What would you do if you found out the home you loved was inhabited by an ancient evil? Would you stay, or would you go?

The Haunting of Minnie Haha

Urban legends tend to change over the years as they're passed down from generation to generation, often until the story being told no longer resembles the original tale at all. Such is the case with the haunting of Minnie Haha in Ionia, a city of eleven thousand northwest of Lansing.

According to the legend, an old recluse who lived in a shack on the edge of town was eaten alive by her dogs, which were vicious and starving after being deprived of adequate care for years. Her spirit now haunts the grounds of Highland Park Cemetery. Visitors to the cemetery have reported seeing statues that move and bleed from the eyes, hearing disembodied shrieks, being overcome with chills even in the middle of summer, feeling as though they are being followed or watched and hearing voices whisper to them.

As frightening as the urban legend might sound, the truth is worse. On March 24, 1957, an Ionia resident made a gruesome discovery. The good Samaritan had gone to check on his neighbor, an elderly recluse who lived in a hillside shack, as he'd not seen her in days and her mail was piling up. He opened the door to find her dead body being mauled by a pack of ten wild dogs, strays that she'd taken in and befriended over time. He immediately notified the police, who had to shoot two of the snarling beasts just to get inside the house. The rest of the dogs fled into the countryside and were never seen again. For years, rumors of a pack of killer dogs plagued the community. Some say that if you visit the site of the old shack, you can still hear the dogs howling in the wind.

While the dogs did make a meal of the old woman, police don't believe they killed her. They believe that she fell ill and died, and with no one to feed them, the dogs went mad and began to feast on her remains. They devoured the majority of her identifiable features before her body was found. What was left of her was buried in Highland Park Cemetery. But her name wasn't Minnie Haha. It was Edna Palmer.

Where the name Minnie Haha (or Mini-Mini Ha-Ha) comes from is unclear. It's possible that, over the years, the true story of Edna Palmer and her wild dogs was somehow combined with an urban legend about the spirit of a Native American warrior named Minnehaha who haunts the graves of Civil War soldiers buried at Highland Park Cemetery. Some believe Minnie Haha is the spirit of a woman buried at Highland Park by the name of Minnie Haas. But by all accounts, Mrs. Haas led a fairly normal life and died a fairly uneventful death, especially in comparison to Edna Palmer.

The true origin of the haunting of Minnie Haha may never be known, but there is one thing most locals agree on: Never, ever, go into Highland Park Cemetery alone. Or at night. Who knows what kind of bloodthirsty beasts might be lurking in the shadows.

Criminal Intent

In the heart of Downtown Charlotte stands a local landmark and cornerstone of the community, the Courthouse Square Museum. The three-story Renaissance Revival–style building, built in 1885, is known for its brick and sandstone façade and its sparkling marble floors. It is also known for the restless spirits said to reside within its historic halls.

The first Eaton County Courthouse, a one-story clapboard shack that resembled a church, was built on the corner of Cochran and Lawrence Avenues in 1845. It was replaced forty years later with the grand building that remains standing today, along with a matching three-story sheriff's residence out back and an old jail that has long since been torn down. Now maintained as the Courthouse Square Museum, the property served as a functional courthouse and jail until 1976. During the ninety years it was in operation, countless verdicts were rendered inside the old courthouse, changing lives forever—sometimes for the better but often for the worse. It is said that the souls of tortured criminals and unavenged victims haunt the building to this day.

There is a common belief that criminals were hanged on the courthouse grounds following convictions back in the 1800s and those are the ghosts that haunt the property. But that simply isn't true. Michigan officially abolished the death penalty in 1846, the year after the courthouse was built. And even when capital punishment was legal, Michigan didn't practice it. It is one of the few states to never have held an execution after being admitted into the Union. That's not to say inmates didn't execute

one another, though…and occasionally themselves. There is at least one account of a man awaiting trial who hanged himself in the jail before judgment could be passed down. Another man, upon hearing the judge's verdict in his case, ran out of the third-floor courtroom and threw himself over the mahogany banister to the second floor below.

Could theirs be the phantom footsteps often heard walking the third-floor corridor, outside the courtroom? It is not uncommon to hear pacing in the halls when seated in the empty courtroom or from the floor below, where meetings and special events are often held. On more than one occasion, visitors to the old courthouse have heard commotion from the floors above them when no one else was supposed to be in the building. Oftentimes, the police have been called for fear that an intruder has broken in. And though footsteps, moving furniture and echoing voices can be heard plain as day, no one is ever found.

Whether anyone has actually died inside the courthouse remains unclear, but many lives have ended there. With a swing of the gavel, judges had the authority to send citizens away for life. That power weighed heavily on many judges, and it corrupted others. One exceptionally tragic case tried in the Eaton County Courthouse was that of accused cop killers James Morehouse and Hawthorn Sutton in 1928.

James "Bugs" Morehouse and Hawthorn Sutton met in Battle Creek as young men. Both were from well-known, well-to-do families in their communities. Both were clean-cut former student athletes with good educations. And both were in love with beautiful women. Sutton had recently married a coed at Olivet College, while Morehouse was engaged to be married to a nursing student at a Battle Creek Hospital. Their lives were just beginning, and they both had bright futures ahead of them.

On Thanksgiving Day 1927, as the men enjoyed a traditional holiday meal with their loves, the conversation around the dinner table turned to financial struggles both young couples were facing. Morehouse proposed an idea. He had a foolproof plan that would make them rich, quick. He and Sutton would steal a car from Battle Creek, drive north to Eaton County, hold up local service stations, then return the car to its parking spot before morning without the owner ever noticing it was missing. If it worked, they would repeat this process until their bank accounts were stacked. Both had significant others in college, and Morehouse was preparing for his wedding, which was just weeks away. The constantly changing vehicles would make it nearly impossible for police to track them. Armed with a .38-caliber revolver registered to Sutton and a .45 Smith and Wesson that Morehouse stole when

The third-floor courtroom at the Courthouse Square Museum. *Courtesy of Erica Cooper, 2018.*

he worked at the Battle Creek Post Office, the men carried out their first heist on December 8, 1927, at a service station in Charlotte, where Morehouse was from. They absconded with $2. Two days later, they robbed a gas station in Eaton Rapids and a pool hall in Mulliken, netting nearly $200. The owner of the gas station died of a heart attack a short time later as a result of the stress from the robbery. On James Morehouse's wedding day, December 14, 1927, he and Sutton robbed two service stations near Battle Creek, where they lived. Their greed was escalating, as was their addiction to the thrill of it all. The following day, they embarked on their most ambitious spree yet. They hit Battle Creek, Eaton Rapids, Grand Ledge, Lansing and Grand Ledge again and returned home to their wives before the sun came up. But their reign of terror wasn't over. Not even close.

On December 16, 1927, the partners in crime started their day of debauchery early. They robbed service stations in Hastings and Grand Rapids, followed by a hardware store in Potterville. They broke into the closed hardware store to get a part they needed to repair their badly damaged stolen car but made off with a load of electronics instead. Then, rather than waste time repairing their car, they stole the hardware store's truck. They drove to Charlotte, where they stole Morehouse's father's Model T Ford

Coupe out of his garage and made plans to ditch the truck. Morehouse, with Sutton following behind in the truck, pulled the Model T into a service station to put air in the tires just as Cleo Platt and his wife were closing up shop at the restaurant they owned across the street. Platt, an Eaton County Sheriff's Deputy, offered Morehouse his assistance.

It was nearly 2:00 a.m. on the seventeenth by this point, and the city of Charlotte was all but deserted. When Deputy Platt shined his flashlight into Morehouse's car, he noticed the stolen electronics from the hardware store. Sensing danger, he sent his wife home and ordered the men into the Model T in an attempt to arrest them. Sutton was behind the wheel, and Morehouse was beside him. Platt hopped up onto the running board and told them to drive to the jail, which was just up the street. Sutton swerved the car, trying to knock Platt off. It didn't work. So Morehouse pulled out his stolen .45 and fired two rounds, hitting Deputy Platt in the shoulder and abdomen. The two men took off into the night, leaving Cleo Platt bleeding to death in the road less than a block away from the courthouse. Platt dragged himself up the steps of the nearby Michigan Bell Telephone Office, where he knew there would be someone working. He lived long enough to tell investigators his account of what happened but passed away that afternoon. Thirty-eight-year-old Cleo Platt was the first Eaton County deputy to die by gunfire. He left behind a wife and two young daughters.

Hawthorn Sutton was quickly arrested in Battle Creek, while James Morehouse and his bride of just a few days fled the state, only to return and be captured almost immediately. Both men were lodged in the Eaton County jail, where Morehouse confessed to pulling the trigger but insisted he only shot Deputy Platt in self defense. He claimed that Platt never identified himself as an officer, just brandished a gun and began barking threats. When Morehouse saw him reach for his gun as they drove down Cochran Avenue, he told Platt to put his hands up. When Platt ignored him, Morehouse fired—but only because he feared that Platt was going to shoot him. His version of events went unheeded. In a trial wrought with so much emotion that even the judge became choked up while reading his verdict, both men were convicted of first-degree murder and sentenced to life at Jackson State Prison. They were transported to the prison that same day. James Morehouse was twenty-two. Hawthorn Sutton was just twenty-one.

Could they be the tortured souls haunting the halls of the Eaton County Courthouse where their lives ended before they'd even really begun? Or could it be the restless spirit of Judge McPeek, who oversaw the trial and never fully recovered from the troubling case and the senseless loss of not

one, but three promising lives? It is common for the lights in the judge's chambers to turn themselves on long after the building has been closed up for the night, and many believe it is due to a judge from the past burning the midnight oil, wrestling with a heartbreaking decision, much the way Judge McPeek had.

While the third-floor courtroom is said to be where the majority of paranormal activity takes place in the building, there have been strange occurrences on the first floor as well. There have been sightings of a young boy in a white button-up shirt who appears out of nowhere and vanishes just as quickly. It is believed that he may be the spirit of a child brought to Michigan on an orphan train, which is every bit as awful as it sounds.

Orphan trains operated in the United States from 1845 to 1927. Predating the foster care system, they were used to transport homeless, abandoned and orphaned children from the oversaturated East Coast to the Midwest, where communities were still being established. There were plenty of families with room to grow and couples who couldn't have children of their own, just as there were plenty of children in need of good homes. The first orphan train arrived in Dowagiac, Michigan, in September 1854 with fourteen boys on board to be placed with new families. While the idea was a good one in theory, it quickly turned into something else. Those looking to adopt from the "baby train," as it became known, began placing orders—choosing children by hair color, eye color, height and skin tone. The whole thing reminds me of this movie I used to watch when I was little called *The Electric Grandmother*, in which families in need of help would adopt a robotic old woman to care for them, but only after choosing her hair color, eye color and body type. Like Build-a-Bear for humans, almost.

After being handpicked based on desirable features by orphan train organizers, children would then travel across the country and be paraded out in front of prospective parents as if at auction. Many of these families were farming families looking for extra hands, not interested in providing the nurturing environment the orphan train riders so desperately needed. Others were looking to bring children into their homes for more sinister reasons, and orphan trains made it dangerously easy. Prospective parents' motives were never questioned, and their backgrounds were rarely checked. The only requirement to obtain a child was a recommendation from a pastor or justice of the peace, and even that wasn't often enforced.

Some 12,500 orphans from New York and Boston were brought into Michigan during the orphan train days, and the Eaton County Courthouse

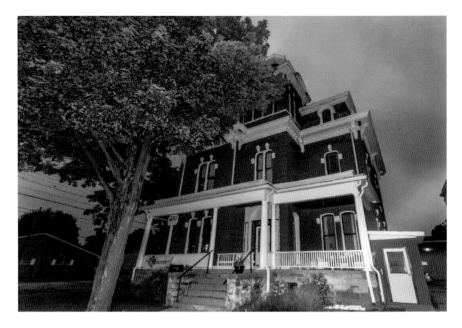

The sheriff's house and women's jail. *Courtesy of Erica Cooper, 2018.*

in Charlotte was a stop along the train's route. Children would be kept in the basement of the courthouse until their new families arrived to collect them. Being that the children often lived in squalor and then traveled across the country under treacherous conditions, many of them arrived ill and weak, and some died before they could be placed in homes. Could that explain the little ghost child that roams the halls of the courthouse? It's a possibility.

Behind the courthouse stands a building that looks nearly identical to it, just on a smaller scale. This served as the sheriff's house and once had a jail attached. While the jail was for male prisoners who would hoot and holler out the windows at passersby, the third floor of the sheriff's house served as the jail for women and sometimes children. If a mother was arrested and had no one to keep her children for her, she would have to take them to jail with her. Though they did spend a good amount of time in the dark, depressing jail with their mothers, the children weren't treated as inmates. They often played in the yard with the sheriff's children and ate their meals in the family dining room. Which was probably a good thing, because the third floor of the sheriff's house is said to be weighted down by heaviness and melancholy. Visitors have reported becoming overwhelmed

with sadness on the third floor and feeling claustrophobic and trapped in certain areas.

It's been nearly forty years since a trial was held in the old Eaton County Courthouse and about the same amount of time since anyone has been imprisoned there. Still, with over one hundred years of dark history—suicides, mob trials, jailhouse brawls, orphan trains, wrongful convictions, murder trials and the like—it's no wonder the Courthouse Square Museum comes alive at night with the spirits of those who aren't alive at all.

Mad Martha

Every small town has its secrets—scandalous moments from history that tarnish a community's otherwise wholesome reputation. Things talked about only in hushed conversation and then eventually not at all. But as one Mid-Michigan town recently discovered, you can erase someone from memory and raze their house to the ground, but you can't always do away with the evil left behind.

Williamston is a city of about four thousand residents located just southwest of Lansing. The quaint downtown area gives off a nostalgic vibe, many of the buildings looking much the same as when they were built in the 1800s. The Red Cedar River winds through the city, and railroad tracks cut right through downtown. It was there along those tracks that a young woman with a history of mental illness by the name of Martha Haney committed a gruesome crime in 1897. She beheaded her mother-in-law with an axe during a fit of rage, then set the elderly woman's head on the dining room table, a knife and fork on either side, for her poor husband to find when he came home for lunch.

With details too macabre to be believed, the story made national headlines for a couple of days before fading into obscurity. Old Woman Haney was buried, her killer was shipped off to the Michigan Asylum for Insane Criminals and their story was forgotten—the townsfolk quick to put the incident behind them. Eventually, the house was demolished, and the Haneys were never spoken of again.

And then in 2015, a retired police officer by the name of Rod Sadler published a book about the Haney murder called *To Hell I Must Go*. He

came across the story by chance while doing some historical research on his ancestors and knew it had to be shared. He breathed new life into a long-forgotten story, inevitably and unintentionally drawing curious fans to the scene of the crime, now an overgrown field tucked back along the railroad tracks. And all that attention breathed new life into something else. If stories are to be believed, Martha Haney still stalks the property of her former home, craving praise for her masterful crime. While experts have different theories about why Martha did what she did and why she's still here, they all agree on one thing. Martha's presence is one of overpowering chaos, and her spirit is not one to ignore.

Relegated to decades of solitude in an abandoned field, Martha began to feed off of the newfound attention Rod Sadler's book created, as it brought visitors to the site of her former home in droves. Excited to share her house of horrors and aching for companionship, Martha is said to try to latch on to anyone who visits her. Over the course of several months, she developed a particularly strong connection to a local medium, Cat Ryan.

The first time Cat visited the site of the Haney home, she was instantly overcome with a feeling of immense glee. Odd, considering the macabre subject matter. She had no doubt that she was channeling Martha's energy. And things only got weirder from there. It wasn't long before Martha started communicating with visitors through a device called an ovilus, essentially a speak-and-spell for ghosts. Spirits are believed to be able to channel their energy into the electronic device to access a vast dictionary within and choose words from the dictionary to communicate with the living. The ovilus is a hotly contested piece of equipment among paranormal investigators, many believing its results to be more coincidental than accurate. But there is no denying the results that occur when visiting the site of the Haney murder. Martha has been known to call people by name on more than one occasion. She has communicated about the layout of her former home, which is now nothing more than a crumbling foundation buried a few inches under loose dirt. Sometimes, she will go into gruesome detail about the murder of her mother-in-law, Mariah. One of Martha's favorite names to call out quickly became "Cat," who she began trying to attach herself to the moment Cat first arrived on her property. Armed with an ovilus, Cat was ready to communicate with whatever spirits might be roaming the abandoned lot. What she wasn't ready for was the strength of Martha's spirit and her determination to connect. Cat's ovilus began displaying words like "befriend" and "pair." She could feel Martha's spirit trying to attach itself, so Cat explained to Martha that while they could be friends, she would not

allow Martha to go home with her. Not one to take no for an answer, Martha reached out again as Cat tried to leave. No sooner did Cat climb back onto the shuttle bus that had delivered her to Martha's home than her ovilus said "shuttle." And for the first time, another member of the team's said "Cat." After that visit, every time Cat visited Martha, the spirited murderess would call out to her through someone else's ovilus, asking for her by name.

Cat believes there are other spirits trapped with Martha as well: her mother-in-law, Mariah, who is said to be ashamed of her daughter-in-law and the spectacle she turned their family into, and Martha's sad, lonely husband, Alfie, who is as passive in death as he was in life. On one occasion, following construction on the property, crumbling remnants of the Haney house's foundation were unearthed. Though not usually a recommended practice, Cat took a small piece of the foundation home with her and instantly regretted it. Following some strange goings-on, she left the jagged rock outside her home, a protective salt ring surrounding it. She believed she'd inadvertently taken the spirits of Mariah and Alfie Haney home with her. So concerned about keeping Martha contained, she never thought to forbid the other family members from attaching themselves. On her very next visit to the Haney home, Martha had a strong message for Cat, which she shared with her psychic friend as soon as she arrived. Immediately upon turning on her ovilus, Cat was met with the words "BRING HER." Martha wanted her mother-in-law back where she belonged so that she could continue to torment her for all eternity. On her next visit to the site, Cat did exactly that, returning the chunk of foundation to where it belonged.

While the strength of Martha's spirit makes her an intriguing entity to communicate with, it also makes her dangerous. According to Christine Peaphon of Mid-Michigan Paranormal Researchers, "Martha is crazy. Absolutely insane. She stalks the land almost like a cat and is very territorial over the property and the other spirits there." In addition to communicating regularly through the ovilus, Martha has been spotted as a shadow figure by visitors on many occasions and picked up as a moving entity on paranormal equipment, roaming the abandoned lot where she used to live. And then there's the laughing. More than once, visitors to the Haney home have reported hearing loud cackling that sounds more human than animal, almost like a witch. While it's possible that the cackling can be attributed to wildlife in the nearby woods, those who have heard it aren't convinced.

I, myself, was once lured in by Martha. On a trip out to Williamston to run an errand, I unintentionally found myself turning on to the dead-end

road that runs along the railroad tracks, pulling up in front of the gaping hole where the Haney home once stood. I turned down my radio, and before I could stop them, the words "Hi, Martha!" escaped my lips. As soon as I realized what was happening, I threw my car into reverse and hauled it out of the area as quickly as I could, not bothering to complete the errand I'd traveled nearly thirty miles for.

To happen upon the unimposing patch of grass where a small house once stood between two trees, one might find it hard to fathom that the property is haunted, still under the control of an insane murderess who died over a century ago. But spend a little time with Mad Martha, give her the tools she needs to communicate with you, and you might just be shocked by what you discover.

The Blood Curse

As urban legends go, there is perhaps none more well known in the Lansing area than that of Blood Cemetery in Laingsburg. According to local lore, the cemetery was once privately owned by the Blood family and was part of the Blood estate, which included a mansion called Blood House. (With a last name like Blood, it just all sounds sinister, doesn't it?) The last residents of Blood House were Dr. and Mrs. Blood. In a bout of insanity, Dr. Blood hacked Mrs. Blood to death with an axe, dismembering her body and burying it in the yard. Once he realized what he'd done, he hanged himself from the crooked tree in the family cemetery, and the Blood family was no more.

The ghosts of Dr. and Mrs. Blood remained on the property, of course, and stories of the haunted cemetery and abandoned Blood House circulated through town over the years, becoming more and more elaborate. One Halloween night, a group of teenagers ventured into the cemetery under a full moon, but only one of them dared to enter the old Blood House. When he failed to resurface despite the pleading cries of his worried friends, the teens sought the help of police. On the way back to the cemetery, the police scolded the children for being so foolish and told them that Dr. Blood's ghost wasn't kind to trespassers. When they arrived back at Blood House, it was engulfed in flames, and the missing teenage boy was nowhere to be found. Once the fire burned itself out, officials found his charred remains in the wreckage. His hands and feet were bound with rope, and there was a bloody axe near his body. In

the cemetery was a freshly dug grave with the decaying, dismembered remains of Mrs. Blood inside. Dr. Blood's body had vanished and was never found.

The story continues that in the 1970s, a group of thrill-seeking teenagers went out to Blood Cemetery after midnight and got so spooked by what they saw, they hopped in their car and sped away. Frantic to put distance between themselves and whatever had frightened them, they ran a stop sign and were hit by an oncoming truck. All but one of the teens was killed instantly. As rescue workers tended to the lone survivor, he repeatedly begged them to not let "it" get him.

According to the legend, anyone who climbs the crooked tree in Blood Cemetery will be shoved out of it by Dr. Blood, possibly to their death. Countless locals have reported seeing a woman—missing her arms and legs—in a red dress floating between headstones. Paranormal investigators have recorded EVPs and reported shadow people, orbs and whispering voices among the trees. While the phenomena experienced by visitors to Blood Cemetery may differ, everyone agrees on one thing—*never* ever go into Blood Cemetery alone. Because Dr. Blood just might not let you leave.

But those are all just stories, right? Yes and no. Much of the lore is based on facts that are just as frightening, if not more so, than the urban legend they inspired. For starters, there was a Dr. Blood, a chiropractor, and he did meet a grisly fate in a tree on his property. On March 1, 1973, Dr. Richard Blood was using a chainsaw to cut limbs from a fallen tree when he lost his balance and dropped the saw on his leg, completely severing it from his body. So it wasn't his wife's body he dismembered, it was his own. And he didn't die or vanish, he simply moved to Arkansas after the incident, minus his right leg. (No word on if the leg was buried in the cemetery.)

Dr. Blood is no one to fear. But Reverend Blood and the cursed Blood children—that's a different story. While many thrill-seekers visit Blood Cemetery around Halloween, it's during the month of March that people should be wary. Reverend Daniel H. Blood settled in Laingsburg in the early 1800s as one of its founding members. He preached at Blood Church, built Blood School and lived in Blood House with his wife, Susan. On March 1, 1842, Reverend and Mrs. Blood welcomed a daughter, Amelia. She lived for just three days, but her short life seemed to set in motion a tragic chain of events for the family, leading many to believe that they'd been cursed. Over the next several years, three of Amelia's siblings followed her in death, all in the month of March. In March 1847, ten-year-old Addy and twelve-year-old Samuel died just ten

The faded grave of the cursed Blood children. *Courtesy of Erica Cooper, 2018.*

days apart. Almost ten years to the day after Samuel's death, five-year-old Alvira died in March 1857. Four young Blood children were buried in the family cemetery in the month of March, three of them girls with names beginning with the letter A. Today, they all share one faded, crumbling headstone. Reverend Blood would succumb to the curse himself many years later. He died on March 2, 1883. What was it about baby Amelia that brought such a curse upon the Blood family? We may never know.

As for the carful of doomed teenagers? That part of the legend is tragically true. In the early morning hours of October 18, 1988, five teenage boys from Lansing took a trip out to Blood Cemetery to look for ghosts. They left the cemetery spooked and became convinced that someone was following them. At 4:45 a.m., their 1980 Oldsmobile Cutlass ran a stop sign on Cutler Road and collided with a tractor trailer. Four of the boys were thrown from the vehicle and killed instantly. Only one survived. And all he remembers about the crash is the driver accelerating to get away from whoever was chasing them. Are the rest of the stories about deaths at Blood Cemetery real, too? Most likely not. But there definitely does seem to be some truth to the legend of the Blood Curse.

House of a Thousand Corpses

Lansing is regrettably notorious for its destruction of historical buildings. While local officials have recently put an emphasis on preserving what few structures remain from the capital city's early days, much of the damage could not be undone. Perhaps no tale is more representative of the blatant disregard for preserving Lansing's history than that of the Barnes Castle. Built in 1875 by railroad tycoon-turned-mayor Orlando M. Barnes, the architectural masterpiece was demolished in 1957 to make room for a grocery store parking lot. Yes, Lansing quite literally paved paradise to put up a parking lot. But before its tragic demise, the twenty-six-room Victorian beauty was the finest mansion in the area, home to two mayors, a contender to become the governor's mansion and eventually a broken-down palace rumored to be haunted by the ghost of the man who built it. Driven to financial ruin by his only child, son Orlando F. Barnes (who also served as Lansing mayor for a time), Orlando M. Barnes passed away in the Barnes Castle in 1899. But many say his spirit lingered. Even in death, he was unable to part with the home that had once been a symbol of his wealth and success. The house stood vacant for decades as rumors swirled that Old Man Barnes's ghost could be seen passing by windows, his deep voice heard hollering down the halls. The castle was maintained by the Barnes family until Orlando's wife died in the home in 1921, at which point it was acquired by the City of Lansing. When the house was finally demolished, the stories about the haunted Barnes Castle disappeared with it. But just south of town, in another grandiose home that members of the Barnes family once

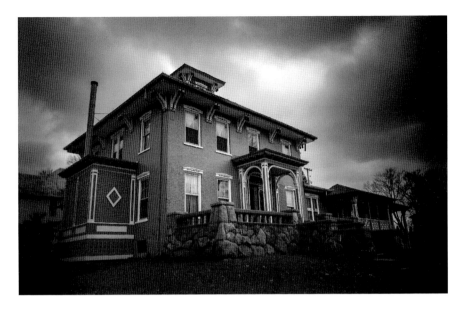

The Jewett House in Mason. *Courtesy of Erica Cooper, 2018.*

resided in, rumors of a new haunting began. Except it wasn't just the ghost of Orlando Barnes that haunted this particular house. It was said to be filled with the ghosts of hundreds, if not thousands, of corpses.

Mason, Michigan, is a city rich with history. Home to just over eight thousand residents, the hallmark of the downtown corridor is the historic Ingham County Courthouse. The surrounding area is composed of new and old buildings, with many structures dating back to the mid-1800s, when the city was first established. Just down the road from the courthouse, atop a hill, occupying nearly an entire city block, sits a beautiful four-thousand-square-foot Victorian Italianate mansion known by locals as the Jewett House.

Built in the mid-1800s by businessman J.P. Coatsworth, the monstrous mansion, with its stone and pillar front entrance and lighted widow's peak, looks every bit as foreboding from the outside as it feels on the inside. While the immaculately maintained original woodwork, open floor plan, marble fireplaces and grand staircase highlight the mansion's undeniable beauty, it doesn't take long for visitors to decide that it's what lurks in the quiet corners of the Jewett House that give it real character. The home's first casualty and oldest ghost is said to be that of Coatsworth's wife, who died inside the house. After losing the love of his life, Mr. Coatsworth sold the home and passed away just a few years later.

While many notables lived in the home over the years, perhaps one of the most famous residents of the home was former Lansing mayor Orlando F. Barnes, who lived there until 1910. After causing his father's financial ruin and untimely death, he lived out the remainder of his days plagued by tragedy. In 1889, he and his wife lost two children under the age of two. It is unclear whether the Barnes family lived in the Jewett House at that time, but it's quite possible that both babies died inside the home. In 1924, Orlando F. Barnes lost his only remaining child, a son, Orlando M. Barnes II, at the age of forty. The following year, his wife, Mary, passed away. After outliving his entire family, Orlando F. Barnes died in 1937 at the age of eighty-one when he lost control of his car on the highway and skidded into the path of an oncoming truck. Given his father's reputation as the ghost of the Barnes Castle, is it possible that Orlando Jr. haunts the Jewett House to this day?

During the Great Depression, the Jewett House served as a teahouse for the community before taking on a new, much more morbid role. In the mid-1930s, a man named Arthur Jewett turned the great mansion into a funeral parlor and the headquarters for his ambulance business. Jewett's Funeral Home was known as a one-stop shop—services were held on the main floor, while bodies were embalmed in the basement. Over the next sixty years, countless corpses came and went from the Jewett House. But were they all corpses when they arrived? It was not uncommon for bodies to occasionally be delivered to a funeral home only for the staff to discover that the deceased wasn't entirely dead. Or worse, for some poor soul to wake up on an exam table in the middle of the night, abandoned by a mortician who planned to begin the embalming process the following day. In many cases, these individuals were mortally wounded or gravely ill and did eventually die, often in the funeral home they'd been taken to prematurely.

Following Arthur Jewett's death in the early 1990s, the funeral home was sold and turned back into a private residence, intended to be a rental property. After reversing many of the changes made to turn the house into a funeral parlor and restoring it to its former glory, the owner never had trouble finding renters. He just had trouble keeping them.

A number of families moved into the giant house during the 1990s and early 2000s, but none of them ever stayed long. One tenant fled the home at 2:00 a.m., not having lived there long enough to even unpack all of his boxes. The house has been vacant since 2014, when a single mother and her daughters left with such haste, they left many of their belongings behind. In 2017, the house was put up for sale. But even realtors and prospective buyers

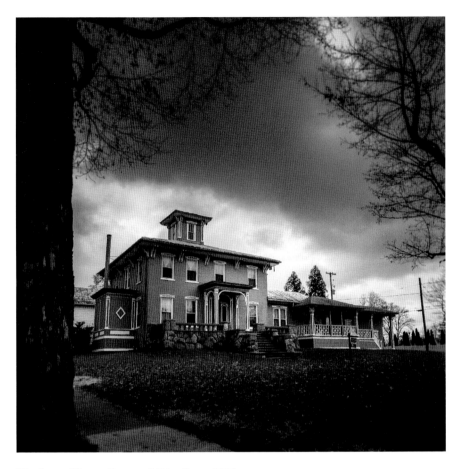

The Jewett House. *Courtesy of Erica Cooper, 2018.*

were not immune to the spirited home's antics, many of them leaving before they'd even finished touring the first floor.

What is it about the Jewett House that terrifies people so? According to Gary Gierke, co-founder of the Michigan Area Paranormal Society, it is the most active location he's investigated, with a number of spirits that regularly communicate with the living.

"I heard voices within the first five minutes of entering the house," recounted Gierke about his first of many visits to the home.

> *We were just arriving and getting ready to set up our equipment. I heard two women talking upstairs and, at first, assumed it was members of the team scouting out the upstairs. I called out "Hello" a couple of times, and nobody*

answered me. And then, from the top of the stairs, I heard a woman's voice say, "They're here." Of course, when I went up to investigate, there was nobody else in the house. That was my introduction to the place, and it's only gotten better.

Gierke says there are several members of the Jewett family still in the home, as well as some spirits whose connections to the home cannot be determined. Most notably, there are two mischievous children, Michael and Rachel, both believed to be between five and ten years old.

Michael has been caught on camera on multiple occasions. He appears as a mist-like figure, sitting on the floor in front of the fireplace, hiding in corners of the garage waiting to jump out and frighten visitors and in an upstairs bedroom. He likes it when people bring him toys and has been known to play with balls and other objects. While he is spotted all over the home, Michael's presence is most strongly felt in a small room in the basement with cobblestone walls and a loose gravel floor. It is here, according to three different psychics, that Michael's remains are buried.

According to Gierke, "We brought a number of psychics into the home, and they all told a similar story about Michael. We believe, for whatever reason, that he spent a majority of his time chained up in that room in the basement, and that when he died, he was buried there." Gierke said his team has recorded multiple EVPs that support that theory. One purportedly of Michael, recorded in the basement, said, "They left me here to stay." And another, an elderly woman's voice, when questioned about Michael's treatment, said, "That's just the way we did things back then."

The spirit of the little girl called Rachel is even more active. She likes to hang out on the grand staircase and is said to tug on people's clothing and touch their hands. She seems to have a fascination with long hair, as many women have reported feeling their hair being played with when on or too near the stairs. Some say Rachel thinks it's funny to push people down the stairs, while others believe she's simply reaching out in curiosity and it's the feeling of being touched that sends people into a panic and results in them falling.

While it is unclear how Michael and Rachel wound up in the Jewett House, one theory involves a practice that dates back centuries. When a family fell on hard times, they would often send their children to live with wealthier members of the community. In exchange for room and board, the children would be expected to work around the house and on the property. This indentured servitude was sometimes only for a short time while the

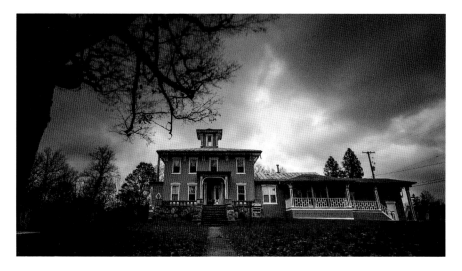

The Jewett House. *Courtesy of Erica Cooper, 2018.*

child's family stabilized their finances but often lasted years. The luckiest of children were welcomed into their new homes and treated like members of the family, while others were forced to live in less than tenable conditions. Such an arrangement would explain why Michael and Rachel cannot be connected to the Jewett House through a paper trail, as these types of arrangements were usually undocumented.

In addition to interactions with the undead children in the Jewett house, common occurrences include disembodied footsteps on the second floor and grand staircase, the sudden filling of a room with the strong scent of cigar smoke or floral perfume, hearing whistling from an empty room, seeing full-body apparitions, hearing voices, the abrupt onset of severe headaches and nausea and worse.

The last residents of the Jewett House moved in fully aware of the home's haunted reputation, so they weren't as easily put off by things that went bump in the night as others might be. In fact, they welcomed a relationship with the spirits. But before long, they began to suffer unbearable experiences, which ultimately led to their decision to leave. A teenage girl living in the home, who'd been a relatively happy child before moving in, quickly became depressed and withdrawn. She suffered from nightmares, insomnia, intense mood swings and even suicidal thoughts. The root cause of her depression was traced back to a dark, heavy presence in her bedroom, which she began spending less and less time in. The family

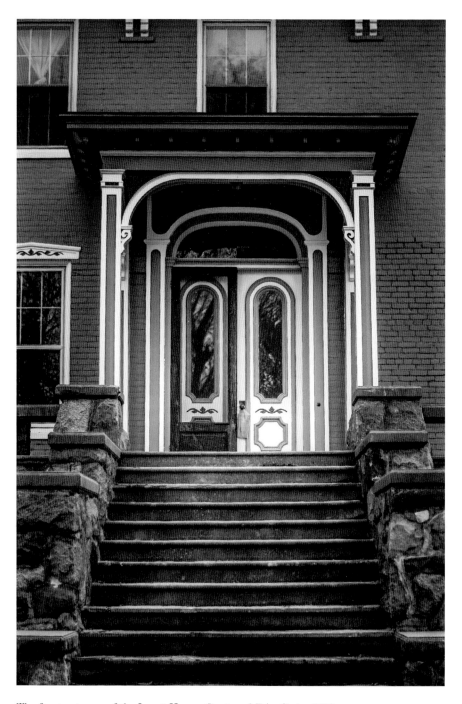

The front entrance of the Jewett House. *Courtesy of Erica Cooper, 2017.*

eventually fled the home with just the essentials, deciding that their well-being was more important than material objects.

For years after the last family moved out, the house sat vacant. Seekers of the paranormal and curious neighbors would often visit the Jewett House to take pictures, peer in the windows and see if they could catch a glimpse of the shadow people that are often seen peering out from behind curtains. On more than one occasion, it has been reported that visitors have found the home's doors wide open, and that if they got close enough, they would hear a man's voice encouraging them to "come in." Those that made the regrettable decision to enter the home without the permission of the owner often wound up having to explain themselves to the police, as neighbors kept a close eye on the abandoned mansion. The house's owner would insist that all doors to the home had been closed and locked, and despite the lack of evidence of any sort of forced entry, the police didn't often accept "being lured by the paranormal" as a valid excuse for trespassing.

When it was put up for sale, the Jewett House had hundreds of prospective buyers walk through its historic halls, but no serious offers for several months. Possibly because of the house's history, or possibly because the spirits in the home would terrify visitors, even those who were only there for a short time. One realtor who had several clients ask to see the Jewett House enacted a personal policy that she adhered to for her own sanity. "She wouldn't go beyond the first floor," Gierke explained with a laugh. "She would keep her hand on the front door and answer her clients' questions by yelling to them throughout the house." Another realtor and his client visited the home on a sunny afternoon, and as they passed by the grand staircase, the fireplace doors began to shake and rattle on their own. The realtor and his client quickly left the home, having only seen a couple of rooms.

With so many personal experiences and so much evidence gathered by experts, it's hard to discount the rumors about the Jewett House. Mischievous ghost children, apparition sightings, disembodied voices—the Jewett House seems to be a plethora of paranormal activity. But is it haunted by the wife of the home's builder and very first owner? Or the tortured soul of Orlando F. Barnes? Possibly by the children of poor local families who'd been sent there to stay? Or those who were brought to the home already dead? With thousands of corpses having passed through the Jewett House over the years, it's impossible to say.

Little Girl Lost

In keeping with the family's wish to remain anonymous, names have been changed.

Most people who buy old houses do so for their character—the crown moldings, the high ceilings, the early American architecture. It's true that they don't make 'em like they used to. Whether that's a good thing or a bad thing is subject to personal opinion. But when people buy an old house, they do so with the knowledge that they're also buying its many years of history. Ghost stories are to be expected, whether they're believed or not. But when one builds their home from scratch, when every 2x4 and section of drywall is straight off the shelves at Home Depot, the expectations are different. A new house is seen as a clean slate, a new frontier where no one else has ever been. One certainly doesn't expect it to be haunted by restless spirits from a time gone by. But that's exactly what happened to one local family shortly after moving into their dream home.

In 2010, the Clark family moved into a brand-new house just outside the city of Lansing. As their two young daughters became acquainted with the other children in the neighborhood and their new schoolmates, it was not uncommon for the girls to mention names their parents didn't recognize. But over time, one name began to stand out—Emily. Both girls were always talking about something Emily did or said and about all the fun they had together. Their parents assumed Emily was a new friend from school and didn't think much of it. Until one day, when one of the girls was gone, and the other asked her mother if she could go play with Emily.

"Where?" her mother asked.

"Outside," the girl explained. Her mother looked out the window and didn't see anyone in any of the neighboring yards.

"Sure," she said reluctantly. She watched as her daughter bounded out the door, toward the swing set. She sat down on a swing and began to pump her little legs back and forth. The empty swing next to her began to also move, but her mother attributed that to the wind. When the little girl started to talk to herself, however, her mother was concerned.

That night, she told her husband, "I think the girls have an imaginary friend."

"Both of them?" he asked. *Yes*, his wife thought. *That is odd.*

A few days later, the mother sat her girls down and interrogated them about their new friend. Every question she asked was met with silence as the girls exchanged glances, then answered in unison.

"Does Emily go to your school?"

"No."

"Does Emily live in the neighborhood?"

"Yes."

"Can you both see Emily?"

"Yes."

"Can Daddy and I meet Emily?"

To that question, the girls had no answer. Their mother asked again, and their answer was chilling. "Not yet."

After that day, the girls stopped talking about Emily. Their parents hoped Emily had simply been a figment of their imaginations and that they were embarrassed to have been caught. But Emily would not stay gone for long.

One night, Mr. and Mrs. Clark awoke in the middle of the night to the sound of the girls giggling and whispering in their room. As Mrs. Clark made her way down the hall, she heard the tinny chimes of a music box and that name again. Emily. She opened the door to find her daughters in their pajamas and tutus, wearing plastic beads and tiaras, dancing to the strange melody of their music box by the light of their nightlights.

"What on earth are you doing?" their mother asked.

"Emily wanted to play ballerinas," one of the girls answered. It seemed she said the words without thinking and regretted them instantly. Her sister gave her a dirty look, and it was clear to their mother that her daughter had revealed something she wasn't supposed to.

"Emily's here?" she asked. Both girls nodded. "Where?" Slowly and reluctantly, they pointed to the corner of the room, near the bookcase. As

their mother flipped on the light, a picture frame fell from the bookcase, shattering on the floor. It was then that she noticed the girls' window was slightly open, even though she was positive she'd closed and locked it when she tucked the girls in for bed. Suddenly terrified, she grabbed both girls by the hand and led them to the living room, turning on every light in the house along the way. She called out for her husband, who sleepily made his way from the bedroom.

The girls were treated to cookies and milk as their father investigated the house for any signs of an intruder. Once he was certain his family was safe, he joined them in the living room. Despite the late hour, it was time to get to the bottom of this Emily mystery. So the Clarks launched a new line of questioning.

"Is Emily in the house now?"

"No," the girls answered in unison.

"Was she here when you were in your room?"

"Yes."

"How did she get in?"

"The window."

"Does she come in through the window a lot?"

"Yes."

"Where does Emily live?"

"Nowhere."

The girls were confused, their parents were on edge and everyone was shaken up, so they agreed to continue their conversation the following morning. That night as she tossed and turned, Mrs. Clark came to a terrifying realization. Emily wasn't imaginary. She was a ghost. The next day after breakfast, the topic of Emily came up again. This time, however, the girls offered a chilling answer when asked about their friend.

"We're not supposed to tell you," they said when their mother asked them where they met Emily. After a long talk about keeping secrets and how parents are responsible for making sure their children are safe, the girls finally agreed to talk about Emily. And the tale they told was one that would shake their mother to her core.

The girls claimed to have met Emily the day they moved into the new house. As they played outside while their parents unpacked, a pretty girl with long blonde hair and big brown eyes approached them. The girls liked her long, flowing nightgown with the ruffles at the bottom and thought it was funny that she had bare feet. She didn't talk much at first but eventually opened up to her new friends. When they asked where she lived, Emily

Courtesy of Erica Cooper, 2018.

would always point to the empty field beside their house where wildflowers grew. She played with the girls outside and eventually started sneaking into their room at night. She liked dolls and dancing and made the girls promise to stop talking about her around their parents. She said she couldn't come over anymore if Mr. and Mrs. Clark found out about her.

The story was too elaborate, too specific to be a figment of the girls' imaginations, their parents decided. Although the truth was nearly impossible to accept, it was even harder to deny. The Clarks were victims of a haunting.

"But how?" Mrs. Clark remembered her husband asking. "How can our house be haunted? It's brand new!" For the answer to that question, they decided to bring in a team of experts. They reached out to paranormal investigators for help.

While the investigators didn't gather much evidence of a haunting during their investigation of the house, the historical research they did seemed to provide some answers. Back in the early 1900s, there was a farmhouse located on the empty lot next door to the Clark residence. In 1929, that farmhouse burned to the ground in the middle of the night. The entire family escaped except for the youngest child, a little girl. Her name, of course, was Emily. The summer after the fire, a field of beautiful wildflowers grew where Emily's family home once stood, and it was decided

that no house would be built on that land again. Before investigators left that night, they said a blessing for Emily and encouraged her to cross over and join her family, all of whom had passed away in the years since the fire. The Clarks never heard from Emily again. But every summer, they would pick some of "Emily's flowers" from the field next door and leave them in a vase in the window for her to enjoy.

WHAT LIES BENEATH

Though it's technically in East Lansing, Michigan State University has long been one of Lansing's claims to fame. Opened in 1855 as the Agricultural College of Michigan with just three buildings, five faculty members and sixty-three students, the five-thousand-acre campus now has nearly forty thousand students enrolled and is one of the largest educational institutions in the country. A national icon and an athletic powerhouse, the Big Ten college has changed a lot over the past century and a half. But the original campus is still there, nestled among the state-of-the-art buildings and dorms. And with it comes countless ghost stories, earning MSU a reputation as one of the most haunted college campuses in the country. But it's the ghosts that lurk beneath the campus that students fear most.

Commonly referred to as "the dungeons," there are several miles of steam tunnels below the MSU campus. Nearly one hundred years old, the tunnels were built to house campus utilities and are still used to provide heat to buildings on campus today. Although the dungeons are forbidden territory and most of the entrances are locked up, determined students still find their way into the maze of tunnels to this day. But do they all make it out alive? Among the stories of ghouls and monsters said to prowl the tunnels, none is more well-known than that of a little boy lost—in life, in the tunnels and then forever.

The student body at Michigan State is ever-changing, thousands of people coming and going from all over the world each semester. It's easy to

get lost in the shuffle. And that's exactly what happened to Dallas Egbert when he enrolled for summer courses at MSU in 1979, even though Dallas was no ordinary student. For starters, he was sixteen. A child prodigy, Dallas graduated from high school when he was fourteen and had already taken classes at a number of universities before attending a semester at MSU. School administrators promised the Egberts that their son would be well looked after, which was the main reason they chose MSU. They knew the classes wouldn't challenge Dallas's brilliant mind. Nothing ever did. Only one in a million people scored as high as Dallas did on IQ tests. When he was twelve, he was called upon to repair computers for the U.S. Air Force. The boy was a genius. But he also was just a boy. Small in stature and said to have the social skills of a seven- to ten-year-old, Dallas struggled to fit in among his peers at Michigan State. And despite the school's promise to his parents that the staff would take good care of Dallas, he was essentially on his own. He lived in a dorm by himself, took classes that bored him and spent most of his free time alone, with very little interaction between him and the school staff.

Perhaps that's why, when Dallas went missing on August 15, 1979, it took five days for the school to notify his family. Because long before he disappeared into thin air in real life, he'd disappeared into the background at a school ill-equipped to tend to his unique needs. Desperate to find their son, the Egberts hired the top private investigator in the country, and media from all around the world descended upon Michigan State University. While it would take a full month for Dallas's fate to be revealed, one theory was born almost immediately. Dallas was lost in the tunnels.

The steam tunnels lying beneath Michigan State University had quite a reputation for untoward activity. While officials were adamant that the tunnels could not be accessed, students and local residents alike knew the exact opposite to be true. In fact, one of the most commonly used access points for trespassers was right outside the administration building. Many students used the tunnels to keep warm while traveling across campus during the winter. But others used it for more sinister purposes. The tunnels were believed to be a perfect escape for the burglars and rapists that stalked the campus. Through them, people could enter and exit buildings completely undetected. The tunnels were a veritable breeding ground for criminal activity; as the campus police believed the tunnels couldn't be accessed, they did not patrol them. There was a dark, dangerous underworld beneath MSU that everyone knew about but nobody talked about.

In the mid-1970s, staff and students alike at MSU found another use for the tunnels. The roleplaying game Dungeons and Dragons had just been released, and some of its most dedicated players developed a live-action version that was played in the tunnels under the school. With slime-covered walls, darkness so black it could drive a person insane, valves that released scalding steam without warning (much the way a dragon might) and vermin climbing the walls, it was the perfect setting for a game meant to take place in dungeons.

A science fiction fanatic, Dallas was an avid player of Dungeons and Dragons and quickly found his way into a group that played in the dungeons beneath the school. Many of these groups included faculty members, which upped the danger factor. The tunnels were forbidden territory. Anyone found trespassing in them was subject to disciplinary action. People could lose their course credits. Their scholarships. Their jobs. And so they decided fairly early on that allowing Dallas, who was said to be extremely reckless and immature, to play with them was too much of a risk. He was a minor, after all. What if he got hurt? What if he told the wrong person? He could take the entire group down with him. Ostracized from yet another social group, one that played live-action roleplaying games underground, Dallas fell into a depression. But he didn't stop venturing into the tunnels. It is said that Dallas regularly went into the dungeons alone, eventually spending more time underground in his fantasy world than he did in the real world. So when he went missing, the tunnels seemed like a logical first place to look. Some said he was distraught over the death of his character in the game and went down into the tunnels to kill himself. Others said he was so obsessed with the game that he'd begun to live as his character and was lurking in the dungeons, completely out of touch with reality. Another theory was that he was playing a game with investigators and had laid out traps and clues to see if they could find him.

For twenty-eight days, authorities searched for the lost boy. The search spanned the country. The story spanned the globe. The entire world watched, waited and prayed. There was a suspicious suicide note, a blatant cover-up, a lack of action by university officials, rumors of CIA involvement, secret organizations, threats, wild curveballs, dead ends—and at the center of it all, a missing child. Then on September 13, 1979, the private investigator hired by the Egbert family located Dallas in Morgan City, Missouri. Alive. Frail and traumatized, it would be days before Dallas would be ready to talk about his month-long ordeal.

As many suspected, he had gone into the tunnels the day he disappeared. Whether to hide or commit suicide, he wasn't sure at first. He just needed to escape his life. Strung out on drugs (some of which he manufactured himself), hiding major secrets from his friends and family (that he was gay and that he suffered from epilepsy), feeling pressure from his parents to be the "perfect child" and not able to fit in anywhere despite how hard he tried, Dallas needed time to think. He was in agony emotionally and wanted it to end. He'd gone into the tunnels prepared for every possibility, so when he decided to take his own life, he was ready. He'd left behind a vague suicide note, as well as a map to where his body could be found. He'd taken enough tranquilizers to kill a horse down into the tunnels with him.

When he woke up the next day sicker than he'd ever been, his suicide attempt failed, Dallas knew he needed help. He climbed out of the tunnels and spent the better part of the night crawling on his hands and knees to the only place he could think to go—the home of a casual acquaintance he'd been romantically involved with on campus. A walk that would take a healthy person minutes took Dallas hours, as he passed out multiple times along the way, still sick from his overdose. His friend, who remains anonymous to this day, found Dallas on his porch just before dawn, took him inside and cared for him until he was healthy.

Then the private investigators arrived in East Lansing, and the pressure was on. As the anonymous friend was over eighteen and Dallas was a minor, the man was terrified that Dallas would be found in his custody and he would be charged with a crime. So he shuffled Dallas off to the home of a friend of his, where Dallas spent several days taking and making drugs for the steady stream of visitors to the home. But after about a week, with the entire country talking about the disappearance of Dallas Egbert, the residents of Dallas's second safe house decided he needed to leave. They woke him in the middle of the night and told him it was time to go, then took him to yet another house to stay.

This house was different from the others. Only one man lived there, and Dallas didn't know him. It wasn't a party house like the last place or a friend's house like the first place. And Dallas didn't feel free to leave should he choose to. He was trapped. A prisoner inside the home of a stranger. One who was very angry at Dallas and the media circus surrounding his disappearance. He was cruel to Dallas, and Dallas felt very unsafe. Too many adults had been involved in the delinquency of a minor—sex, drugs, lying to authorities. To just turn him over to his family would put an entire

community in jeopardy. Dallas was worried he would be killed. But after a few days, it was decided he would leave the state instead.

He was given explicit instructions to take a bus to Chicago, then a train to Louisiana. In New Orleans, he was to contact a phone number he had been given. It is the belief of investigators that had Dallas called the associates of the man who'd been keeping him, he would have been sold into sexual slavery. But things didn't go as planned. The train ride from Chicago to New Orleans was a long one, and Dallas was alone with his thoughts once again. All he'd wanted was to die. And when that didn't work out, he just wanted somewhere to belong. Instead, he wound up pawned off on a child predator who sent him across the country for God knows what. Dallas decided his original plan was still the best one. When he arrived in New Orleans, he spent the last bit of money he had on a cheap motel room and the ingredients to make cyanide, which he concocted easily. He mixed it with root beer and downed it. But once again, his attempt at suicide failed. He woke up the next day violently ill, but alive.

Broke, alone and more depressed than he'd ever been, it would only be a matter of time before Dallas found a way to end things for good. He wound up in Morgan City, Louisiana, and found work on an oil field. His employer provided him with a shack to sleep in and enough food to keep him going. After just four days as an oil field worker, Dallas reached out to the private investigator hired by his parents and a few days later was back home. The strange, disturbing saga of the disappearance of Dallas Egbert was over. In the end, many of the theories about what happened to him proved to be at least partially true. He had run away. He had attempted suicide. Twice. He had been kidnapped. And he had been playing a game with investigators. The media moved on to the next big story, the university worked to put the entire mess behind them and Dallas and his family began to heal.

There were months of therapy. Dallas enrolled at a university near his home. He took a job working for his father, an optometrist. He got his own apartment. And then, on August 16, 1980, exactly one year and one day after he vanished into thin air, Dallas Egbert, a child prodigy who'd captivated the world, died of a self-inflicted gunshot wound. There couldn't have been a more tragic ending to such a bizarre story. The memory of Dallas still haunts those who knew him to this day. And some say that Dallas himself haunts the university where things went so recklessly off course.

It's said that you can often hear Dallas crying through the tunnels at MSU from the ground above. That those who continue to trespass have seen him, either curled up in the corner of a dark alcove crying or running by in a

flash—a small, nimble shadow. He's been known to play tricks on those who venture into the tunnels—pulling hair, grabbing clothes, calling out to people, attempting to get them lost. A number of books have been written about Dallas's case, including one by the private investigator who brought Dallas home. One of those books was turned into a made-for-TV movie that was released in the early 1980s starring a very young Tom Hanks as the character based on Dallas. In death, Dallas seemed to finally find the acceptance he spent his entire life looking for.

A lot has changed at Michigan State University since "the steam tunnel incident," as it is often called. But sadly, a lot hasn't. And while they are more secure now than they have ever been, the steam tunnels are still there, beckoning students to explore them. Pitch black, rodent infested, reeking with the stench of death, slime coating the walls and floors, dangerous as ever—who knows what lies beneath. Whatever it is, Michigan State University wants it to stay buried.

BLESSED BE

Just west of Lansing is the city of Grand Ledge. Once a farming community, now a mecca of modern technology with over ten thousand residents, the town's claim to fame is an area known as the Ledges, an outcropping of three-hundred-million-year-old sandstone rock formations lining the shores of the Grand River. Today, the Ledges are popular among hikers, photographers and rock climbers. They form the perimeter of Fitzgerald Park, a seventy-eight-acre recreation area with miles of trails, baseball fields, a nature center and a peculiar red barn with a storied past. While the park is a popular destination for area residents year-round, it also fascinates paranormal investigators with its strange history and reputation for being haunted.

In the early to mid-1800s, Native Americans led by the great Chief Okemos used the area, which they called "Big Rocks," for hunting, fishing and mining coal. Legend has it that once, a Native American mother threw her seven sons into the river to save them from a rival tribe. They all drowned. Where each son landed, an island formed, creating the Seven Islands of Grand Ledge. As settlers invaded their lands and pushed them from their homes, Native Americans began using caves at the Ledges to hide stolen horses, which they would then sell to sustain the new way of life that was being forced upon them. It's said that the caves were also used to harbor runaway slaves en route to Canada by way of the Underground Railroad.

In the late 1800s, the Seven Islands Resort was established along the Ledges, complete with hotels, swimming areas, a zoo, restaurants,

playgrounds, a ballroom, a theater, the first roller coaster in Michigan and a ferry service to travel between islands. Seven Islands quickly became the second-largest tourist destination in the state, and Grand Ledge became only the second city in the state to have electricity. One of the islands was also said to have a mineral spring, which people believed possessed healing properties. It became known as a veritable fountain of youth, and folks came from all over the state and beyond to try it.

Around the same time, on the banks of the the Ledges and the Seven Islands Resort, a spiritualist camp was established. Spiritualism, which was very popular in the United States in the late 1800s and early 1900s, is the belief that the living can communicate with the dead through guides into the spirit world. The goal of spiritualists is to make that communication possible through séance and meditation, so a pavilion was built to hold secret ceremonies. During the fifteen years the spiritualist camp was in operation, hundreds of séances were held behind closed doors at the pavilion. Was the location chosen because the veil between the dead and living was believed to be especially thin in that area? Or did the spiritualists open a portal into the spirit world through their work, allowing the dead to walk freely into the land of the living?

The Ledges Playhouse, formerly a séance hall for spiritualists. *Courtesy of Erica Cooper, 2018.*

By the mid-1900s, Seven Islands Resort was abandoned, the spiritualists left camp and the fountain of youth was forgotten. The séance hall is now a venue for local theater companies called Ledges Playhouse, the islands have all but disappeared into the river, the hotels have been demolished and the mineral spring has vanished. But paranormal investigators claim that fragments of the past remain, even if they can't be seen. The area is popular among those looking to record EVPs. Everything from tribal chanting to spiritualist prayer and children screaming in delight at the amusement park has been picked up on recordings. Shadow people are often seen inside the former séance hall, which is said to give off an eerie vibe, and residents of neighboring properties have been reporting strange goings-on inside their homes for years.

There is a long-held belief that spirits are drawn to water and that sedimentary rocks like those that form the Ledges can hold spiritual energy as well. Add to that Native American legends, séances to communicate with the dead and a mystical spring with healing powers, and there is probably no more ideal place in the Lansing area for paranormal activity. While there is much to do and see at Fitzgerald Park, take a quiet moment near the big red barn, which sits on the cliffs of the Ledges, just above where a Native American mother murdered her children in an attempt to save them from a much more gruesome fate. You might be surprised by what you find.

The Monster under the Bed

Just outside of Lansing is a three-mile stretch of road separating the capital city from its nearest neighbor to the west, the city of Grand Ledge. Once a two-lane dirt road dubbed Suicide Saginaw due to its overabundance of accidents, Saginaw Highway is now a five-lane paved thoroughfare that is traveled by thousands of vehicles every day. While the highway and the communities it connects have gone through major transformations in recent decades, the houses that line that particular section of Saginaw Highway haven't changed much. Many of them are century-old farmhouses, some with the farms still in operation. Nestled among them is an unassuming little house, white with green shutters, that doesn't stand out from its neighbors in any discernable way. But this particular house, which is passed by thousands of commuters on any given day, has been named one of the most haunted private residences in Michigan by paranormal investigators. Why, though? Was it the scene of a horrific crime? Was it built on a Native American burial ground? Years of research have turned up almost no history on the home. The truth about hauntings is that sometimes there simply are no solid answers. A house doesn't need a good backstory to be haunted, however. It just needs someone to haunt.

She'd heard the stories before she moved in but never paid them any mind. The disembodied voices, the apparitions, the little ghost boy who liked to play tricks. She knew about the investigations—the countless photos, videos and voice recordings captured as evidence of the paranormal within the walls of the house. But as a nonbeliever, none of that mattered

to her. The young single mother needed a fresh start for herself and her son, and this house could provide that for them. So in the dead of winter, she moved into the 1920s-era Cape Cod with the hope that the rumors were just that—rumors. The home's spirits wasted no time proving to her how very real they were.

One of her first nights in the home, she'd just turned out the lights to go to bed when she was startled awake by a loud scraping noise. It sounded like some sort of animal trying to claw its way through the walls. Too terrified to move, her thoughts turned to the many stories she'd heard about strange, unexplainable noises in the house and the ghosts believed to be causing them. The noise tormented her throughout the night, starting back up every time she began to fall asleep. Once morning came, she felt ready to investigate. She found that the noise was coming from the home's ancient range, which had an old twist timer with a buzzer. Only problem was, the timer was turned off. She hadn't even used the stove or the oven yet. And when she turned it on to test it, the sound of the buzzer going off was much different from the sound that kept her awake all night. She checked with the former tenant of the home, who'd just moved out a month prior. Never in five years did that tenant have an issue with the range timer. Still, the strange clawing sound continued intermittently over those first weeks until the range was removed from the house altogether.

Toward the end of her first week in the home, the tenant was relieved that her young son was finally getting used to his new room. He had the entire second floor to himself. One night, he was upstairs in bed while his mother was down in the basement organizing boxes. All of a sudden, she heard a loud bang from upstairs, too loud for her tiny four-year-old to make unless he'd jumped from the top of the refrigerator to the floor. To assure her that she hadn't imagined it, the pull-string hanging from the light in the unfinished basement began to sway back and forth. Before she made it up the stairs, the clawing sound from the range began again, and she heard the frantic footsteps of her son as he raced down to the main level of the house from the second floor. He was crying, hysterical, talking about the monster in his room that had woken him up. Needless to say, he didn't sleep in his bed that night. And that wouldn't be the last time the little boy would speak of this monster.

A few weeks later, the woman returned home after a long weekend away to find her home completely disheveled. The dining room table was pulled away from the window and tilted askew. The pedestal mirror in the living room had been moved into the center of the room. And her son's bed

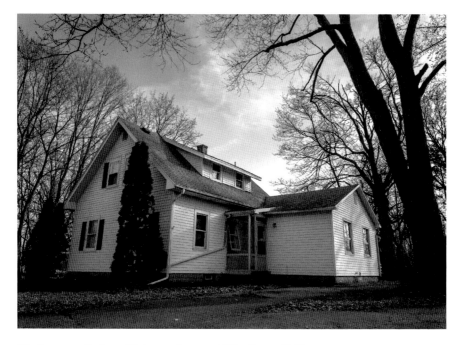

The house on Saginaw Highway. *Courtesy of Erica Cooper, 2017.*

upstairs had been pushed away from the wall. She called her landlord to confirm that nobody had been in the house while she was gone. He assured her he hadn't been there or sent any of his employees over. Nobody else had a key. There was no logical explanation for the house to be in such disarray. And yet, a few days later, it happened again. She'd been home alone with her son all day, and they'd been outside taking advantage of the nice weather. When they went back inside, she found that the dresser in her bedroom had been moved quite far away from the wall. The TV that sat on top of it was teetering on the edge, rocking back and forth, about to fall, as if the movement of the dresser had just occurred.

Yes, she'd heard the stories about the house being haunted before she moved in. She didn't believe in ghosts then, but she believed now. And what was happening to her felt different than the experiences she'd been told about. It felt more forceful, more overpowering than anything the prior tenants reported. It was almost as if the spirits were angry about something. It's a common theory among paranormal experts that spirits, especially those living in houses, don't like change. They tend to become more active when a house is undergoing renovations or significant work. When I lived

The basement of the Saginaw house. *Courtesy of Erica Cooper, 2017.*

The dilapidated barn out behind the Saginaw house. *Courtesy of Erica Cooper, 2017.*

in my haunted house, I couldn't so much as rearrange the furniture without upsetting the delicate balance of sharing my living space with nonliving entities. Were the spirits in the house angered by the change in tenancy? The prior residents had lived there for several years, and over time, the spirits seemed to adjust. The paranormal activity became so sparse, they could go several months without a single incident. Prior to them moving in, the house had been vacant for a long time. And then within a month's time, they were gone, all of their things were gone and a new family with new things had moved in. Would the spirits ever get used to their new roommates? Would they settle down?

So far, no. Strange occurrences have continued to plague the new tenants of the house on Saginaw Street. Probably the most disturbing is the little boy's relationship with an imaginary friend he calls "my monster." His mother will often find him talking to and playing with the invisible being when nobody is around. The boy is no longer afraid of his new friend. In fact, he relays messages for him. He has said that the monster lived in the house a long time ago, and he recently told his mother that the monster says they have to "get out."

Is the monster simply a figment of the young boy's imagination, a playmate conjured up to keep him company in his new home? Or is there something more to it? Paranormal experts familiar with the location claim that one of the strongest spiritual presences is that of a boy named Bobby, who either lived in the house or worked on the farm that the land was once a part of. He appears to be from the early 1920s, and is believed to have died in a tragic accident on the property when he was very young. Could he be the monster the little boy is so fond of? Whatever this monster is, and wherever it's from, one thing is clear—it's not going anywhere anytime soon.

CONCLUSION

Despite the increasingly cynical world we live in, studies suggest that up to 50 percent of Americans believe in the paranormal. (And those are just the ones willing to admit it.) The concept of ghosts is based on the primordial belief that a person's spirit exists separately from the body and continues to exist after that person dies. Since the beginning of time, tales of spirits returned from the dead have been woven into the folklore of cultures around the world, resulting in ghost stories dating all the way back to ancient Egypt. The theory behind haunted locations is that these spirits are often attached to an occurrence or emotion from their past, such as a former home or the location where they died. Traditional signs of a haunting include objects that move on their own, strange sounds and disembodied voices, sightings of ghostly entities and the feeling of being watched or followed. There are believed to be thousands of haunted properties around the country, many of which have been verified as paranormally active by experts in the field.

But why, in a day and age where no one seems to believe in much of anything anymore, do we still believe in ghosts? There are a number of reasons. We often use belief in the supernatural as a coping mechanism when faced with the loss of a loved one or our own mortality. Many of us need to believe that there's life after death. We rely on the paranormal to explain the unexplainable. It's just the way our brains are wired. We need to know why and how things happen. So when an event occurs that defies all logic and reason, we turn to the paranormal. Ghosts are also a way for us to

Conclusion

feel connected to the past. The belief that our ancestors are watching over us makes many of us feel like we're a part of something bigger, an ongoing story in this strange world we live in.

Ghosts range from the notorious to the obscure. The spirit of Anne Boleyn has been one of the most commonly spotted apparitions in all of England since her beheading at the hands of her husband King Henry VIII in 1536. Abraham Lincoln is said to haunt his former stomping grounds and is commonly spotted around Washington, D.C. One of the most infamous hauntings in American history is that of the Bell Witch in Tennessee, which centers on an otherwise unknown family that was tormented by an evil entity in the early 1800s.

Haunted locations can be anything from an abandoned asylum to an empty lot, and they are everywhere in America. Every town seems to have that one house that everyone talks about or that one secret that just won't stay buried. If you believe yourself to be the victim of a haunting, there is more likely than not a team of paranormal investigators in your area that would be happy to assist and guide you, whether your goal is simply to find answers or to banish any entities that may exist from your home. All you have to do is ask.

While many are skeptical of the paranormal due to a lack of science-based evidence, the supernatural phenomena experienced for centuries by people all over the world cannot be discounted simply because it pushes the boundaries of our beliefs. With advancements in technology, paranormal investigators are learning more about the undead than ever before and hope to soon be able to provide incontrovertible evidence that ghosts walk among us. Until then, we'll still have our ghost stories. I hope you've enjoyed reading some of mine.

And as for my very first ghost story? Thanks to the treasure-trove of information known as the internet, I was able to dig up some data on the real-life crime that inspired the legend. The Jolly Superette on the corner of Jolly and Pleasant Grove Road was owned and operated by an Italian immigrant who lived in the apartment upstairs with his wife and their two young children. On December 9, 1966, a customer arrived midday to find the doors locked and the lights on. From the apartment above, she could hear a child screaming. She called the police, who noticed signs of a struggle upon entering the store. In the upstairs apartment, they found the shop owner's wife dead from a gunshot wound to the head, her lifeless body underneath the dining room table. The gun used to kill her was sitting atop the table, and her hysterical three-year-old daughter was in a crib a few feet away crying

Conclusion

"Mommy's dead!" The shop owner said he and his wife had been arguing down in the store when she took off up the stairs to retrieve the gun they kept under their mattress. He claimed he wrestled the gun away from her and was sitting in the living room with it in his lap when she charged at him, causing the gun to go off accidentally. The shop owner was arrested and charged with second-degree murder, which was later downgraded to manslaughter. A judge found him innocent of those charges. Throughout his trial, he was free on bond. He never served more than a day in jail for the killing of his wife. And he did indeed return to his store after the shooting and was open for business. So, not exactly the story I remember from my youth but worse, in a way. The truth is often much scarier than fiction, after all.

Resources

To read more about some of the cases featured in Haunted Lansing, *the following books are recommended:*

Bernstein, Arnie. *Bath Massacre: America's First School Bombing*. Ann Arbor: University of Michigan Press, 2009.
Dear, William. *The Dungeon Master: The Disappearance of James Dallas Egbert III*. New York: Houghton Mifflin Harcourt, 1984.
Malcom X. *The Autobiography of Malcolm X*. New York: Grove Press, 1965.
Sadler, Rod. *To Hell I Must Go*. Denver, CO: Outskirts Press, 2015.

Learn more about the experts featured in Haunted Lansing *here:*

MARTER PARANORMAL RESEARCH TEAM, FOUNDED BY MARK AND TERRI BRIONES
Marter Paranormal Research Team (M.P.R.T.) is dedicated to the scientific, logical and objective approach toward investigations into claims of paranormal activity. www.marterparanormal.com

Resources

Medium Cat Ryan
Cat Ryan is a psychic, medium, tarot counselor and astrologer based in Lansing, Michigan. She seeks to empower clients spiritually, mentally and physically through her services. www.catryanmedium.com

Michigan Area Paranormal Society, co-founded by Gary Gierke
Gary was born with the gift to see auras and sense spiritual energy. He has eleven years of experience as a paranormal investigator and is an expert on the Jewett House.

Michigan State Paranormal Investigations, founded by Keith Daniel
MSPI is dedicated to the research and investigation of paranormal claims of activity. Their mission is to assist families and business owners in understanding odd events taking place in their individual dwellings and establishments. www.michigan-paranormal.com

Mid-Michigan Paranormal Researchers, founded by Christine Peaphon
MMPR strives to find answers to paranormal activity through research and education, and offers house cleansing and sealing services. Find them on Facebook under Mid-Michigan Paranormal Researchers.

Motor City Medium Rebecca Smuk
Rebecca is an empathic medium who helps individuals connect with the other side. She is also the host of the podcast *The Paranormal Fringe* and co-founded GLAS Paranormal with her husband, Dan Smuk. Find her on Facebook under Rebecca S. Smuk The Motor City Medium.

Photographer Erica Cooper
Erica Cooper is a freelance photographer in the Lansing area. To see more of her photos from the *Haunted Lansing* series, visit her website: www.ericajophotography.com

To learn more about Lansing history, visit the Forest Parke Library and Archives, a division of the Capital Area District Libraries. www.cadl.org

About the Author

Lansing native Jenn Carpenter is an avid writer, lover of the paranormal and true crime junkie. She has written for a number of publications over the years but discovered her true passion when she founded Demented Mitten Tours, a true crime and paranormal touring company based out of Mid-Michigan. When she's not regaling the masses with her macabre tales, she's often enjoying a quiet night at home with her husband, their four boys and four dogs. Her interests include renovating her family's century-old Victorian abode, taking weird vacations and binge-watching *Game of Thrones*.

Visit us at
www.historypress.com